WEYMOUTH & PORTLAND THEN & NOW

IN COLOUR

GEOFFREY PRITCHARD & ANDY HUTCHINGS

First published in 2012

The History Press
The Mill, Brimscombe Port
Stroud, Gloucestershire, GL5 2QG
www.thehistorypress.co.uk

ISBN 978 0 7524 8105 0

Typesetting and origination by The History Press
Printed in Turkey.

CONTENTS

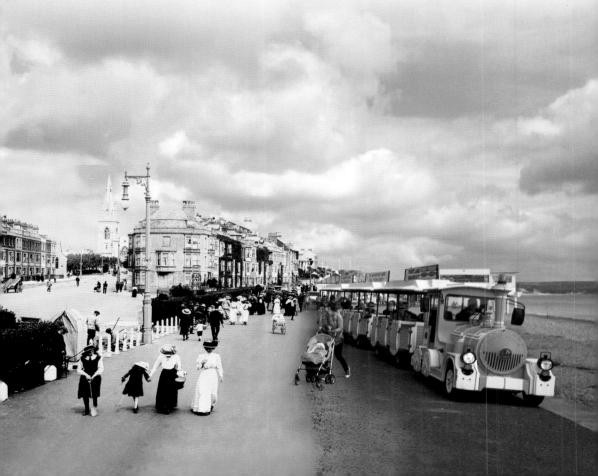

ACKNOWLEDGEMENTS

The authors wish to thank all those persons who have assisted them in the compilation of this book: Maureen Attwooll and Stuart Morris, who read the text and kindly offered some helpful suggestions; Richard Clammer for his advice on paddle steamers; and Geoff's wife, Marcia, for her constructive comments and support.

ABOUT THE AUTHORS

Geoffrey Pritchard has lived in Weymouth from a very early age, and was educated at Weymouth Grammar School and Bournemouth College of Technology. His career in local government spanned thirty-seven years until his retirement in 2003 as Senior Committee Administrator.

Andy Hutchings was born in Weymouth and served for twenty-four years as a Weymouth and Portland Borough Councillor. An Honorary Alderman of the Borough, he now serves on a number of public bodies and is a volunteer member of the Weymouth to Bristol Rail Partnership. He is an avid collector of Edwin Seward postcards.

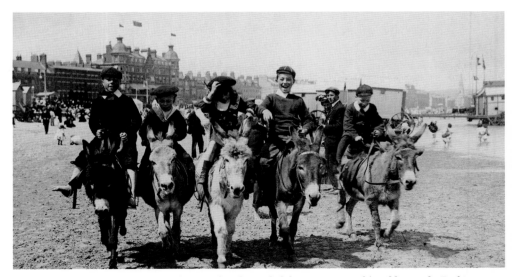

The smiling faces of the children set the scene for a happy holiday on Weymouth's golden sands. Bathing machines complete the picture of a typical early twentieth-century seaside scene.

INTRODUCTION

This book originated from a collection of postcards of Weymouth and the surrounding area belonging to Andy Hutchings, some of which he inherited from his maternal grandmother. Andy noticed the high quality and interesting subjects of those taken by Edwin Seward and he began to collect cards of the area by this postcard publisher. The collection grew and now numbers nearly 3,000 cards. This led to the publication of *Images of England: Weymouth and Portland* in 2004, the captions to which were written by Geoff Pritchard. The present book contains forty-five of the images from the original book, together with contrasting views taken in 2011. These photographs cover the period from the late nineteenth century to the first decade of the new millenium.

Edwin Seward's active professional life spanned the last years of the nineteenth century and the first four decades of the twentieth century. Although he died in 1954, aged seventy-seven, he took very few, if any photographs after 1939. But what changes took place in the time Edwin Seward was taking photographs, and what further changes have taken place since then?

The contrasting pictures, which I took eleven years into the twenty-first century, show, in some cases, a completely different scene and are symptomatic of different attitudes in many fields. The postcard, apart from its role as a memento of a past holiday, served as a means of communication for many people in the days before modern technology had opened up a myriad of communication possibilities. At that time, the numerous postal deliveries and collections meant that it was possible to send a postcard to your relatives telling them that you would be home that evening! The reduction in frequency of the postal services since then has been accompanied by an upsurge in ingenious methods of communication. Texting, the internet and other continually developing means of spreading information have overtaken the popularity of the picture postcard, although many seaside visitors still send a 'wish you were here' postcard to those at home.

Although the street layout of Weymouth and its environs remains largely the same, there have been many changes. The port, once used by commercial vessels, has, apart from the Condor cross-Channel services, become an area largely used by recreational craft. Some buildings in the borough were destroyed in the Second World War air raids; others have been demolished and replaced with new developments. Year round short breaks have supplemented the traditional summer holiday of a week or fortnight stay at the seaside and this is reflected in hotels and guest houses, now better suited to modern tastes. The motor age has been with us for many years, and one of the challenges when taking the present-day photographs was to find a time when the streets were not congested by parked and moving vehicles. This was not always possible and some were taken at risk to personal safety!

Portland's major changes in recent years have included its development as a commercial port, following the departure of the Royal Navy and the opening of the prestigious National Sailing Academy.

What does the future hold? Who knows? Edwin Seward, if alive today, would no doubt have moved with the times and would be displaying his superb photographs (taken digitally) on the internet for all to see. Meanwhile, please enjoy the view and the new captions I have written!

Geoffrey Pritchard, 2012

ESPLANADE NEAR PIER BANDSTAND

A VIEW OF the Esplanade along Brunswick Terrace, showing the bandstand that stood there from 1907 to 1938. A small crowd is being entertained by a band concert but others stroll past, appearing rather uninterested. Hedges occupy the space now taken up with raised flowerbeds, and the small white stones connected by chains show the boundary of the Esplanade. The sender of the card comments 'still the same old donkeys here'. Donkey rides on the sands continue to be a popular attraction for children. The concession was operated by the Downton family from Victorian times until the 1990s.

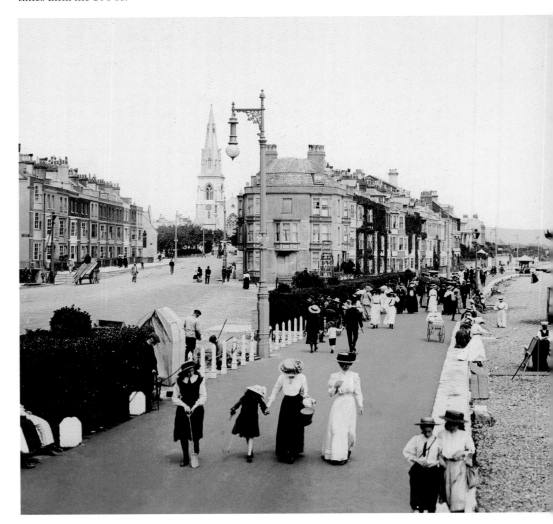

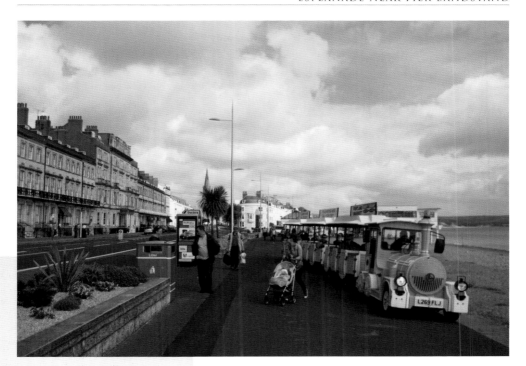

MOST RESIDENTS AND tourists pass this point at some time during the course of a year, and, conveniently, the 'land train' is passing. Travelling from the Sluice Gardens at Greenhill to the King's Statue, this train is a popular feature during the summer months and has been a tourist attraction since 1988. The bandstand, shown in the earlier view, was replaced in 1939 by the Pier Bandstand, which became a popular venue for beauty contests, concerts, roller skating and professional wrestling, but its lack of a roof caused problems in wet weather. The front of the building was an art deco design, although additions in 1958 altered its appearance for the worse. It included Pullinger's Restaurant, a 'silver service' restaurant and favourite venue for a past generation of residents and visitors. However, in the 1980s it was found that the piles supporting the pier needed major attention and as repair costs were prohibitive, the pier was blown up in 1986. A competition was held and the winner pushed the plunger which detonated the explosives. The section of structure still remaining can just be seen behind the land train. The landward section of the building continues in use and is still very recognisably art deco in style despite alterations. The restaurant continues, though in different ownership.

QUEEN VICTORIA STATUE

THE STATUE OF Queen Victoria, photographed in 1905. The bronze statue was sculpted by George Simonds and unveiled in 1902. At that time it was the practice to erect statues in honour of monarchs and other worthies – although it should be noted that Victoria, unlike George III, her grandfather, had little connection with the town. She visited it only briefly on two occasions, once before she had been crowned. The absence of any form of vehicular traffic is typical of the period of the photograph.

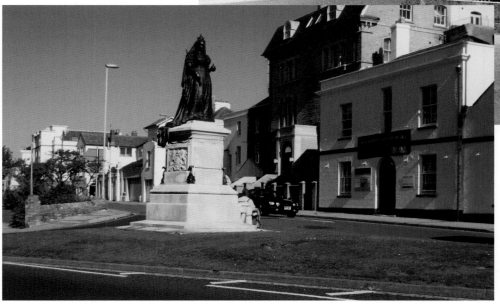

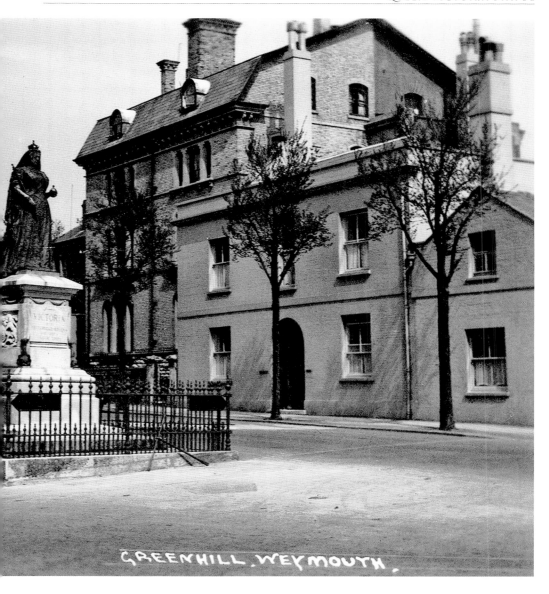

GREENHILL. WEYMOUTH.

THE STATUE, ALTHOUGH still in situ, now stands at the start of a gyratory traffic system implemented in 1964, under which Preston is accessed by means of a one-way system via Dorchester Road and Westerhall. Two highway officials in fluorescent jackets undertake a traffic survey to monitor the heavy traffic flow. The buildings immediately to the right are still recognisable though they have been converted to apartments, the latest development being indicated by a prominent advertisement. The railings surrounding the statue have long since been removed. In the late 1950s, painted footprints appeared from the base of the memorial heading in the direction of the Esplanade. Was this the monarch's ghost? The mystery was solved with the subsequent appearance of a number of university students in the local magistrates' court.

WAR MEMORIAL

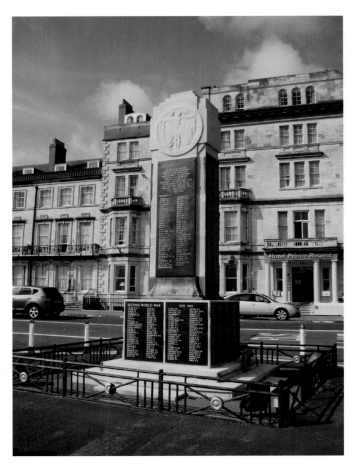

THIS MEMORIAL TO Weymouth residents killed in the First World War was unveiled in 1921. Unfortunately, some ten years later the stonework was eroding. The names of the Fallen, together with the addition of many names previously omitted, were etched on bronze plaques added to the face of the monument in 1932. The War Memorial is the site of a civic service held on Remembrance Sunday each year. In recent years the Royal British Legion has held an additional short service on November 11 when this date does not fall on a Sunday. The plaques commemorating Second World War casualties from Weymouth and Melcombe Regis were added in 1997 following a campaign by a local resident. Previously they were commemorated in a Book of Remembrance dedicated in 1950 in St Mary's church. The plaques have blended in well with those commemorating servicemen killed during the First World War. An adjacent later memorial, unveiled in 2005, commemorates Anzac troops from the First World War, many of whom were stationed at camps in Westham, Littlemoor, Chickerell and Portland. Some died here, including those badly wounded at Gallipoli in 1915, and they lie in Melcombe Regis Cemetery, Newstead Road, beside a memorial erected in 1925. The Australian street names of the Westham Council Estate are a reminder of these soldiers, whose army huts once occupied the land.

IN 2011 IT was suggested that the names of residents who have died in conflicts since the Second World War be added to the Esplanade War Memorial. At the time of writing this was being considered by the Borough Council.

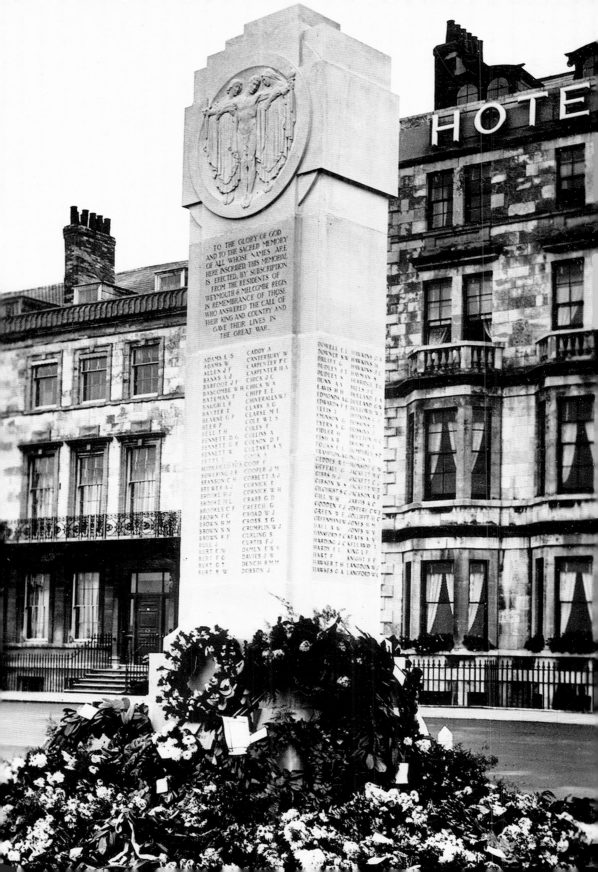

VIEW FROM GREENHILL GARDENS

GREENHILL GARDENS WERE originally
laid out from 1872 and paid for by
Sir Frederic Johnstone, a local benefactor,
who presented them to the borough as a
coronation gift thirty years later. Over the
twentieth century various amendments
to the layout have been made with the
addition of tennis courts, a pitch and
putt course and a bowling green.

IN OCTOBER 2011 the view across
the bay to the Nothe and Portland still

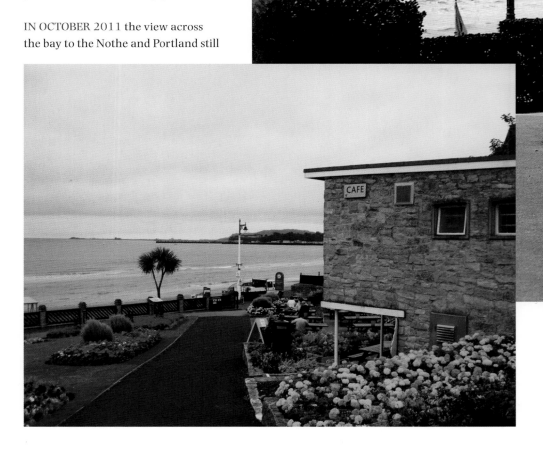

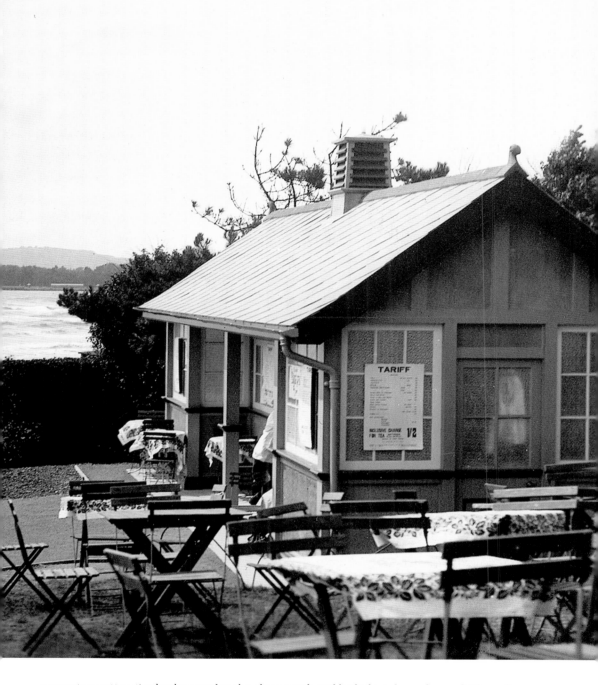

presents an attractive background to the photograph and looks largely unchanged. The café building shown in the original photograph has been replaced twice since then, but remains an added incentive to tarry in the gardens and enjoy a cup of tea and something to eat. The floral displays, planted and maintained by the borough council's gardeners, continue to enhance this attractive area of the town and remain the subject of many postcards and favourable comments by residents and visitors alike.

GREENHILL GARDENS CHALETS

A POPULAR FACILITY at the northern end of the Esplanade is the terrace of beach chalets at Greenhill, which was constructed in the 1920s. The chalets were enjoyed by the local residents and continue to be so today.

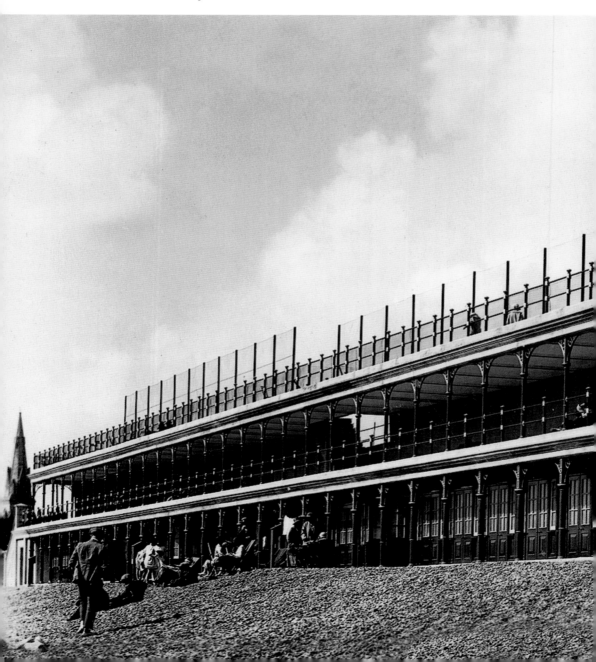

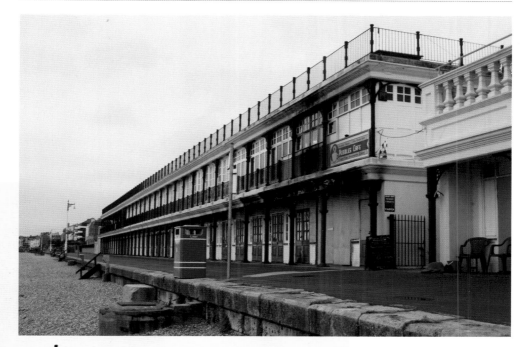

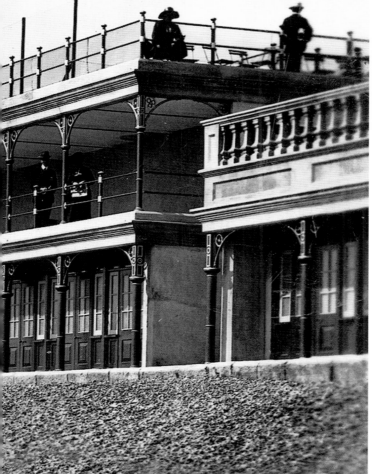

THE CHALETS ARE now in great demand by families and there is a long waiting list to rent one. They are expensive to maintain and their future has been the subject of many hours' debate by the borough council. A major scheme for the enhancement and development of the gardens included a plan to demolish the existing chalets and provoked a great deal of controversy. Following a local campaign, the chalets were designated listed buildings. In this photograph there is evidence of a fire which severely damaged two chalets and caused smoke damage to others in 2011.

ESPLANADE NEAR JUBILEE CLOCK

THE JUBILEE CLOCK was unveiled in 1888 to commemorate the Golden Jubilee of Queen Victoria in the previous year. The tower was paid for by public subscription and the clock was the gift of Sir Henry Edwards. Only in the early 1920s was the clock painted in its present bright colours. In the List of Buildings of Special Architectural or Historic Interest it is described as 'a florid but characteristic enrichment to the seafront – boldly coloured,' and Pevsner's *Buildings of England* series refers to it as 'just the thing to hang fairy lights on.'

Originally, the Jubilee Clock stood on a stone plinth on the beach. It has never moved but the Esplanade was the subject of a widening scheme in the early 1920s, and the clock now stands on the landward side of the Promenade. This was one of a number of measures initiated by the borough council for the relief of the unemployed after the First World War. Other such schemes included the construction of Westwey Road (opened in 1932) and the building of a swimming pool (although this did not materialise until 1974).

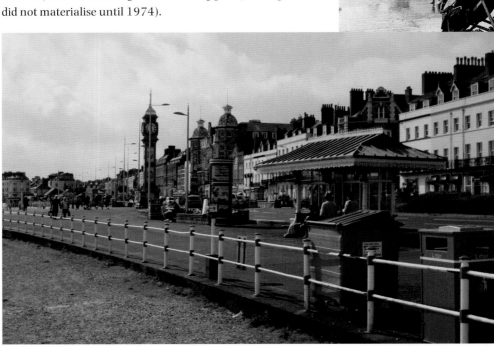

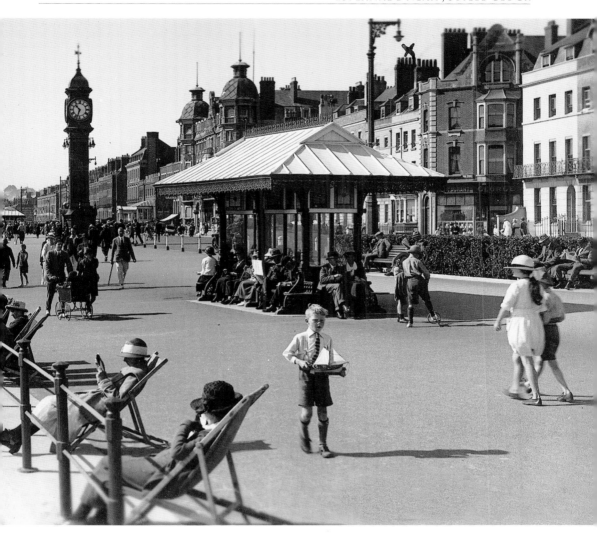

This photograph, taken in 1937 towards the end of Edwin Seward's active life as a professional photographer, shows a small boy walking past carrying his yacht. One can only hope that he did not try sailing it from the beach. The sender of the postcard commented 'the stores here do not amount to much – there are better ones in Yeovil.'

THE JUBILEE CLOCK continues to maintain its role as a Weymouth landmark on many modern-day postcards and both it and the Victorian shelters have recently been refurbished as part of a scheme to improve the Esplanade. The traditional coloured lights have recently been removed and controversially replaced with laser lights. The 'wheelie bins' are a necessary but aesthetically unpleasing addition to the twenty-first-century street scene. Holidaymakers sit on the edge of raised flowerbeds, which were installed in the 1980s, and the 'rotunda' type advertising boards inform the public about events in the Pavilion complex.

GLOUCESTER AND ROYAL HOTELS

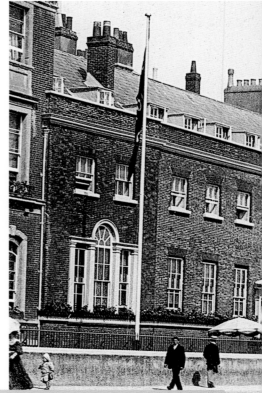

KING GEORGE III first visited Weymouth in 1789, staying at Gloucester Lodge, a house built on the Esplanade by his brother, William Henry, Duke of Gloucester. So much did he enjoy his visit that he spent fourteen holidays in the town between 1789 and 1805. The private residence was sold in 1859 and converted into a hotel, and a large extension was constructed on the southern end.

The construction of the Royal Hotel was started in 1897 and it opened two years later. The building, in a vigorous Northern Renaissance style, was designed by C. Orlando Law. It was a popular venue for civic events and society dinners.

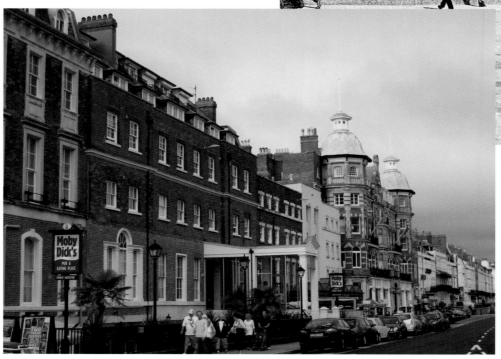

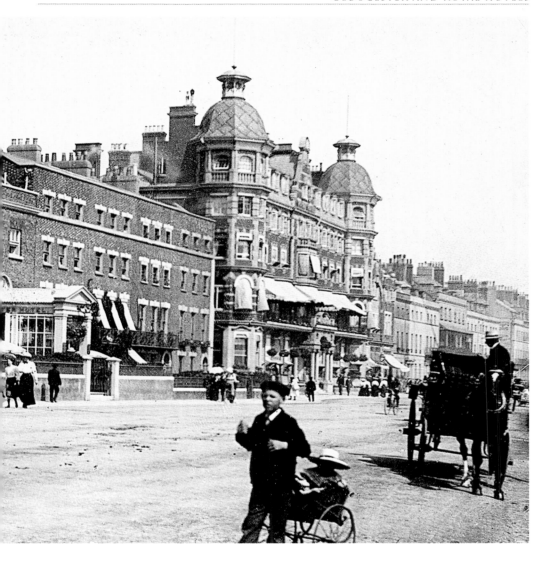

FOLLOWING A DISASTROUS fire in 1927, an additional storey was added to the Gloucester Hotel. However, the building was converted to apartments in 1985 after a number of years of decline as a hotel and a pub now operates in the lower ground floor. The Royal Hotel, however, still operates successfully for its intended purpose. The shops in the adjoining arcade have now become part of an amusement arcade, with the exception of Rossis ice cream parlour, which for the last seventy-five years has been a favourite port of call for generations of residents and visitors alike.

South of the Royal Hotel, Channons, who were the agents for Morris cars, operated a showroom with servicing facilities in Royal Yard at the rear. This use ceased in the 1960s. Note the vast increase in traffic from the earlier picture. The modern-day photograph was taken at risk to life and limb!

ROYAL TERRACE

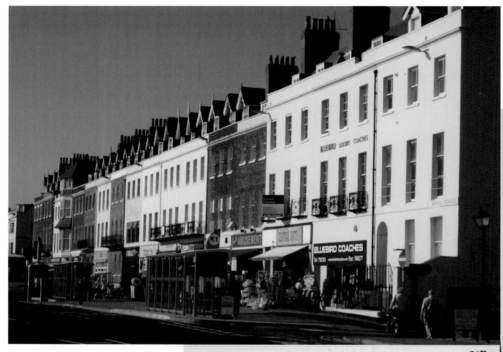

THE PHOTOGRAPH ON the right shows an uninterrupted view of Royal Terrace before the encroachment of shop fronts at ground-floor level. This terrace was developed from around 1815. One building at the left end of the terrace was demolished in 1929 for the widening of the junction with Westham Road.

IN ALL BUT three cases the original frontages have been replaced to create shops, and the steps and railings to nearly all the Royal Terrace buildings have disappeared.

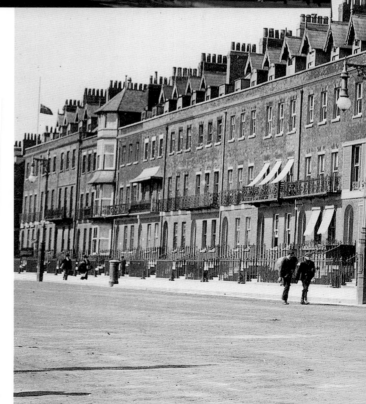

No. 10 has traditionally been occupied by the legal profession. Prior to the Second World War, the firm of De Gex and Atherton occupied the premises, its principal, John Atherton, also acting as Superintendent Registrar for Weymouth and District. A well-known local sportsman, he lost his life whilst serving as an army officer during the invasion of Normandy in 1944. Until 1972 Philip Wickham, partner in Wickham and Lloyd Edwards, served as Superintendent Registrar, and it was here that registry office weddings took place. Passing residents and visitors would stop to view bride, groom and guests as they posed for photographs outside the building, often with consequent delays to other pedestrians! Modern bus shelters on the now crowded pavement denote that this has now become a major arrival and departure point for the town's buses.

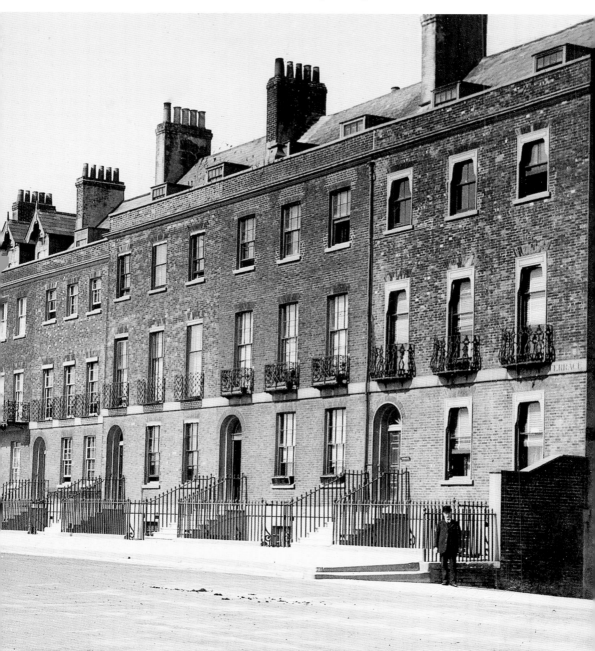

KING GEORGE III STATUE

THE KING GEORGE III statue, a focal point in the life of the town, was first approved in 1802. It was constructed of Coade stone in Lambeth and arrived in Weymouth by sea in 1804. However, due to a long standing difference of opinion between local personalities, delays occurred and the whereabouts of the yet un-erected statue was a mystery. Eventually, the foundation stone was laid in 1809 by two of George's children (his visits to Weymouth having ceased) and the statue itself was unveiled the following year. Its siting has occasionally been a subject of controversy, and there have been suggestions

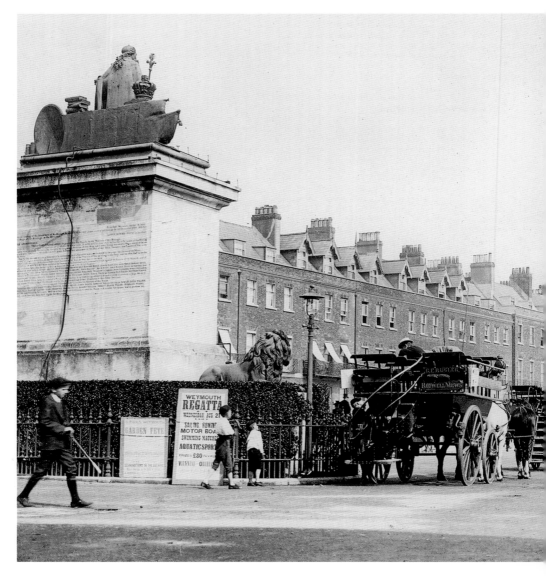

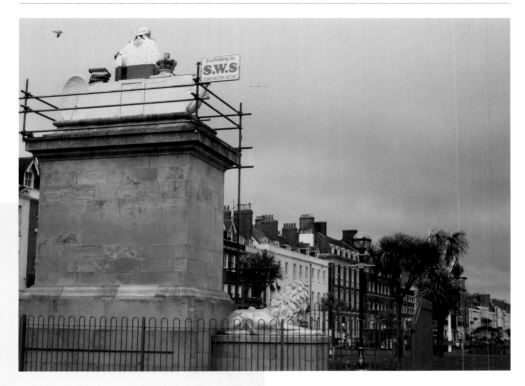

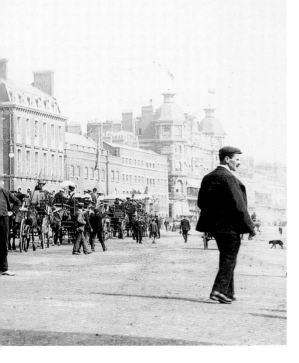

in the past that the King's statue should be moved, but the Grade I listed monument has remained firmly in place for more than 200 years and looks set to stay for the next 200.

ALTHOUGH THE STATUE of King George III retains its prominent place on the Esplanade, the volume of traffic has often meant that passers by do not have the opportunity to admire it. It was first painted in heraldic colours in 1949, and in 2008 major restoration and repainting works began on this important landmark – hence the scaffolding that surrounds it. The statue now stands on a traffic island, allowing motor vehicles to move round it but not park beside it as the horse buses used to! The Weymouth Regatta advertised in the old photograph no longer takes place; the carnival has become the main event for the town in August. St Paul's fete, however, still continues.

VIEW FROM ESPLANADE

THE OLD PHOTOGRAPH shows a peaceful scene, looking across the bay. The produce available on the stall looks interesting and includes bottled beer and bananas. The original Pavilion Theatre of 1908 stands proudly in the background.

THE MODERN VIEW shows the 1960 Pavilion Theatre in the background. This replaced the original structure of 1908 which had been severely damaged by fire in 1954 and was

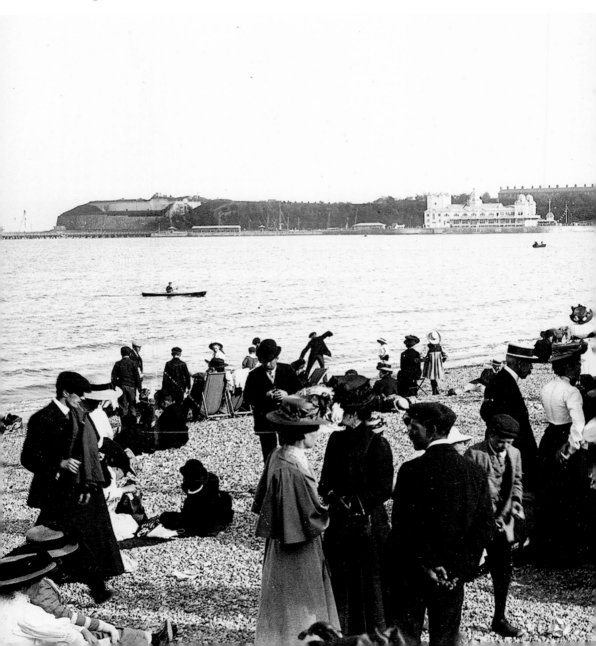

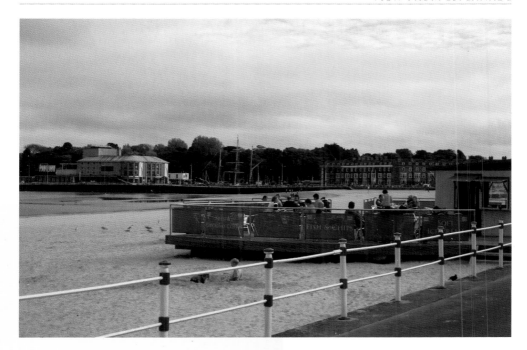

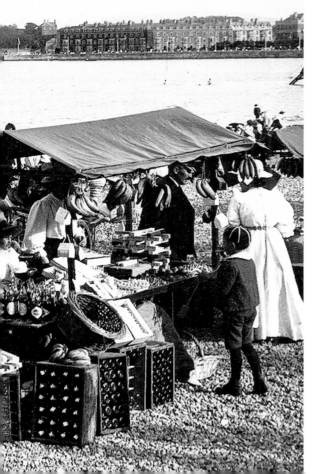

subsequently demolished. Various schemes have been put forward for the redevelopment of the Pavilion, without any conclusion so far. Surprisingly, moored to its right is a sailing vessel, providing a link to the previous photograph. On the beach beside the Esplanade, the modern refreshment stalls with their decking provide a wider variety of fare than that on offer previously.

The Nothe Fort, seen in the background of both photos, ceased to be used for military purposes in the 1950s and was sold to the borough council in 1960. After many years' deliberations, including an abortive scheme for a luxury hotel, since the mid 1980s it has been operated under lease by Weymouth Civic Society. It provides a great number of attractions, including displays, concerts and re-enactment events and the Fort is now one of Dorset's major historical and tourist attractions.

HELTER-SKELTER

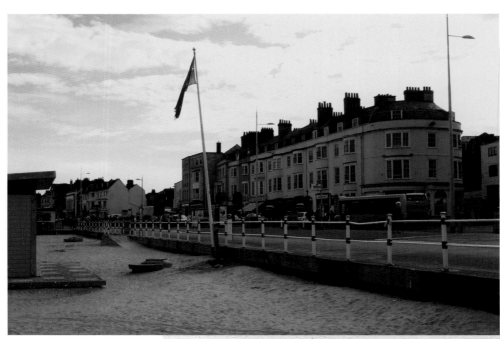

THE HELTER-SKELTER, shown here in 1923, had just recently moved from an area north of Westham Bridge. It proved to be a popular attraction before the Second World War. Properties in Johnstone Row, with their bow-windowed fronts, are largely intact, and J.C. Talbot's estate agent's business was to occupy Statue House for many years to come.

AFTER THE SECOND World War, during which time attractions were

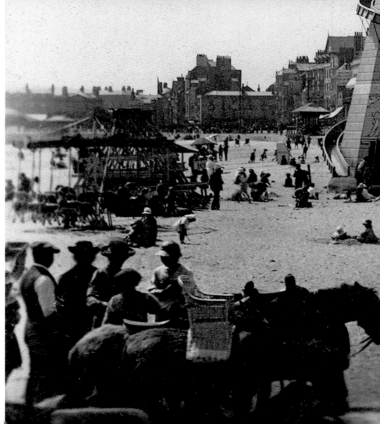

removed from the beach, the original helter-skelter was not replaced, although from time to time similar seasonal attractions appear on this section of the beach. Indeed, most recent travel writing about Weymouth beach mentions the helter-skelter. The level of the beach is much higher than in the earlier postcard and railings now prevent people from falling over the edge of the pavement. Statue House remains as an elegant end to this section of the Esplanade.

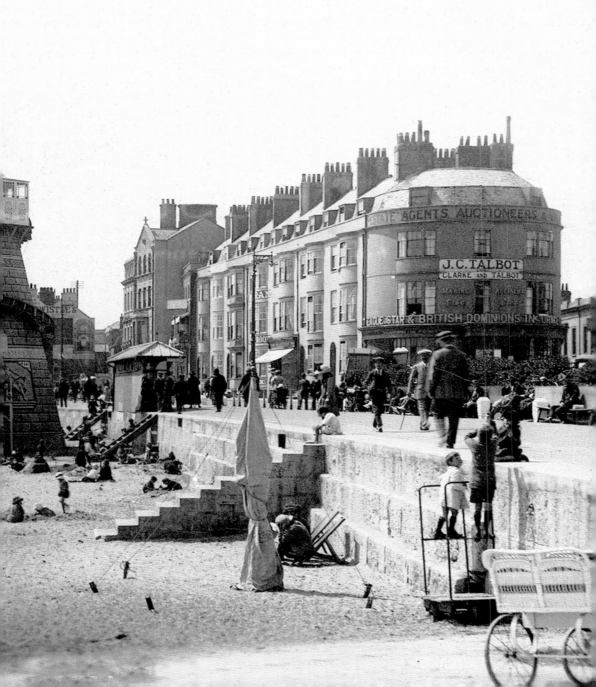

CLARK AND
ENDICOTT MEMORIAL

RICHARD CLARK AND John Endicott set out from Weymouth to the New World. Clark left
in 1583 to join Humphrey Gilbert's expedition to Newfoundland and survived a shipwreck.
Forty-five years later, in 1628, Endicott left Weymouth on the *Abigail* for New England, and later
became Governor General of Massachusetts.

 On Tuesday 2 June 1914 the memorial to these two adventurers was unveiled outside the
Pavilion Theatre by Mrs Joseph Chamberlain, one of Endicott's descendants.

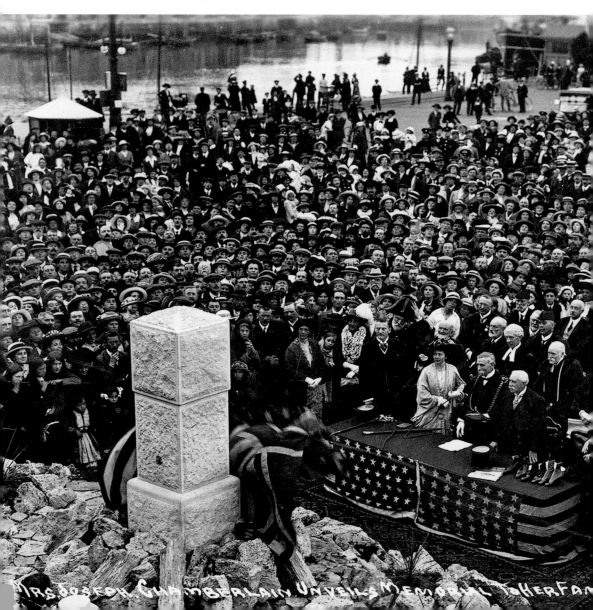

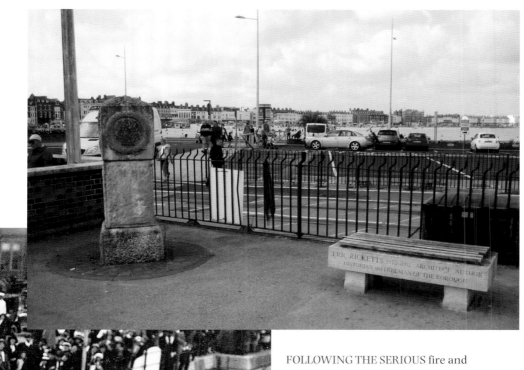

FOLLOWING THE SERIOUS fire and subsequent demolition of the Ritz, the memorial was removed in the late 1950s and went into storage at the Corporation Depot but found a home some ten years later in the Alexandra Gardens.

Weymouth Civic Society had long felt that the memorial was not displayed to advantage and that a more suitable location was near the Ferry Steps, close to the point of the embarkation of Clark and Endicott and not far from its original site. It was unveiled in March 2003 and at the same time a stone seat was installed in memory of Eric Ricketts, who had died the previous year. Eric was a professional architect and local historian, and for many years he was a prominent member of the Civic Society. His enlightened views on conservation were widely respected. He was awarded the Honorary Freedom of the Borough of Weymouth and Portland in 1994, an honour infrequently granted.

HARBOUR NEAR
FERRY STEPS

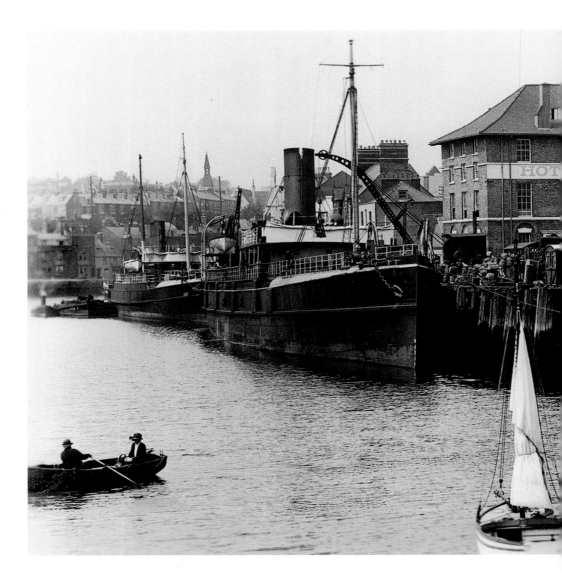

THE OLD PHOTOGRAPH shows the cargo stage and Ferry Steps in the early 1920s. The *Pembroke* is alongside the cargo stage, with a coal barge alongside. The *Pembroke*, built in 1889 and scrapped in 1925, had an interesting career. Built as a paddle steamer for the Great Western Railway's Milford to Waterford service, she was rebuilt as a twin screw steamer in 1895 following an accident. She undertook relief work on the Channel Islands route at various times and spent

periods laid up or for sale. At the time of the old photograph she was at the end of her career, and she was broken up on the Firth of Forth in August 1925. The Edward Hotel had been built around 1800 as a bank and had been converted into a hotel trading successively under a number of names. To the left of the *Pembroke*, the bell turret of Holy Trinity School in Chapelhay is visible. The school was built in 1853 and subsequently extended on several occasions. It was severely

damaged on 17 November 1940 when a landmine fell on Chapelhay; the school was demolished in 1961. A ferryman can be seen plying his trade with only one passenger.

IT WAS DIFFICULT to take a photograph from exactly the same location, so the opportunity was taken to enjoy a passage on the harbour ferry, which still runs as in the previous picture and is crewed by long-serving local boatmen. The Edward Hotel was closed in 1980 and converted to apartments with a bar in the basement. The cargo ships have long since departed, and now only visiting yachts moor alongside the Cargo Stage. This still remains a very picturesque place and is extremely popular with visitors.

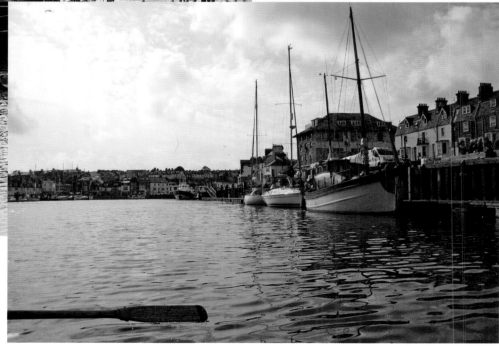

HARBOUR NEAR
SAILING CLUB

THE *ANTELOPE* ALONGSIDE the cargo stage with another vessel astern. Quite what the seafarer is doing peering into the water is a mystery.

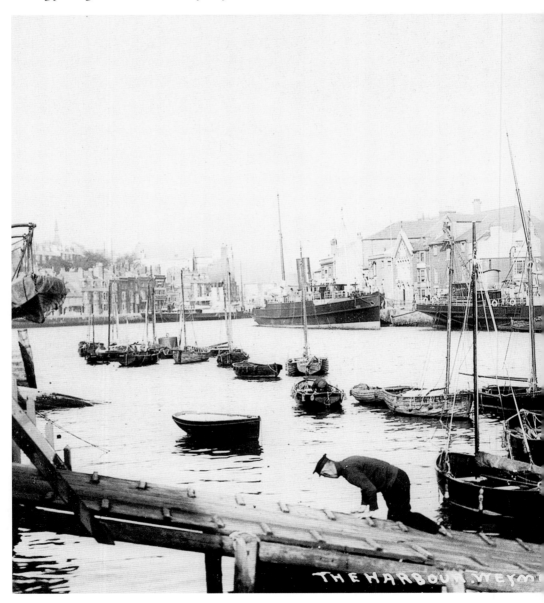

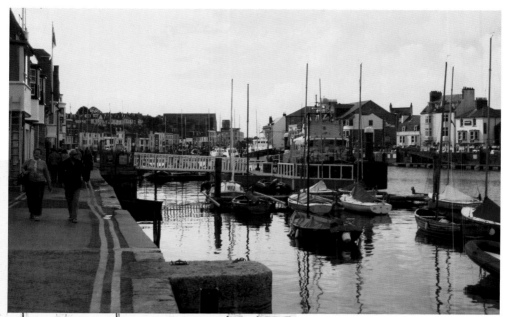

ALTHOUGH WEYMOUTH IS still a major port for sailing to the Channel Islands with the successful Condor hydrofoil, other commercial traffic has disappeared. However, it remains a popular port for sailing craft and other pleasure vessels. Weymouth and Portland waters are the venue of the 2012 sailing Olympics and Paralympics. In this picture dinghies still moor outside Weymouth Sailing Club premises. Just above where the seafarer is peering into the water now stands a jetty, servicing the lifeboat. The original facilities of the Royal National Lifeboat Institution have been much improved. However, they are still based in the lifeboat house, which was extended in 1924 as a result of a gift from Albany Ward, a cinema proprietor who established his first permanent cinema in Weymouth. The imposing church of Holy Trinity still dominates the background.

OLD HARBOUR

AT WHAT TIME of the day did Seward take this photograph? Possibly on a Sunday afternoon, as very few people are in evidence and the harbour is also similarly deserted. Look at the fine buildings lining Trinity Road, and the old Town Bridge.

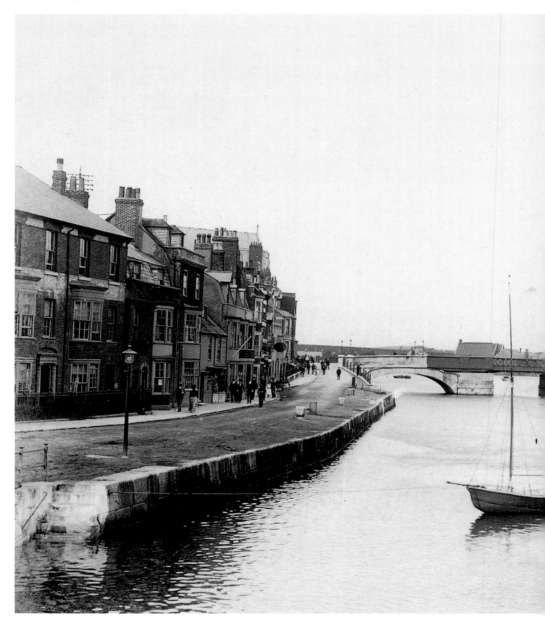

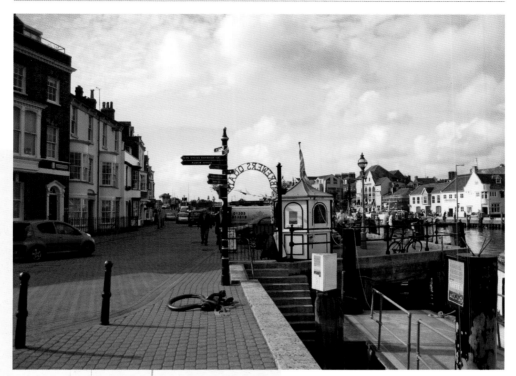

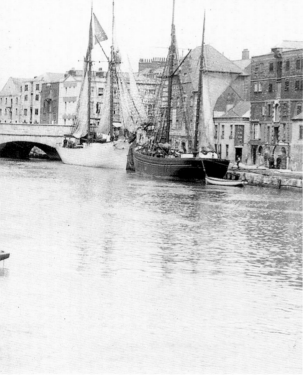

THIS AREA HAS been upgraded as part of the 'Old Harbour' now marketed as a tourist attraction. The highway has recently been re-laid with brick setts. On the former sand jetty, which occupied the bottom corner of the original picture, kiosks sell tickets for the boats, which offer pleasure cruises and fast rides. An attractive cast-iron arch advertises Brewers Quay, which until 2010 housed shops and the town museum and is currently closed for redevelopment and refurbishment. Properties in Trinity Road have been restored and some of the commercial premises previously housing businesses such as fishing-tackle stores have become high-class restaurants and antique shops. This area certainly seems busier in 2011 than in the earlier photograph.

SHIP INN

THIS PICTURE IS dominated by the 'Red Warehouse', erected about 1805 by George Hyde, with two additional storeys added slightly later, a fine feature in the street scene. At the time of the picture, it was occupied by, amongst others, Board Brothers' typewriting school and Eldridge Pope's bonded store. The adjoining Ship Inn possibly dates from the seventeenth century, although its origins cannot be accurately assessed. The large advertisement is for Strong and Williams, whose shop premises in St Thomas Street were demolished prior to the Second World War.

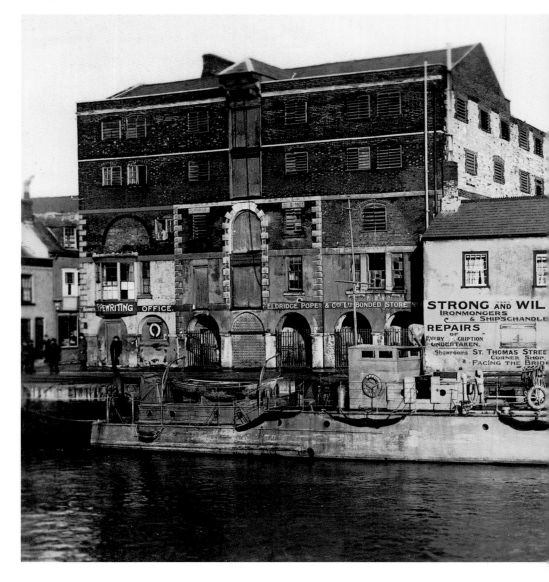

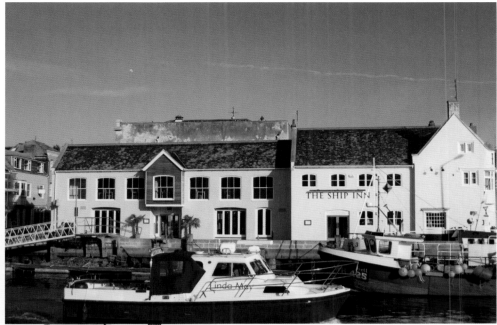

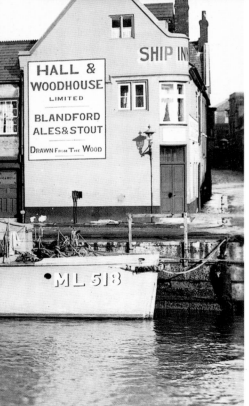

THE 'RED WAREHOUSE' was demolished in 1958, a great loss to the stock of interesting buildings in the area. The reason given was its poor condition, although independent architects who had assessed it stated that it was capable of restoration. The site remained empty for twenty years, being used as a car park, until an extension to the Ship Inn was built. This was recently refurbished and its appearance was considerably altered in 2010. Behind it towers the rear wall of the Guildhall.

Flood defence walls have been erected along this stretch in an attempt to reduce the disruption caused by extremely high tides. The rising water made passage along this section of Custom House Quay and under the Town Bridge very difficult, with unwary motorists often attempting to wade through water to their parked cars. Indeed, before the construction of the flood defences, a combination of high tides and the passage of a vessel in the Harbour would create a minor surge. This often extinguished the Guildhall boilers, much to the consternation of Jim Goodenough, the long-serving Sergeant-at-mace and Guildhall caretaker.

TOWN BRIDGE

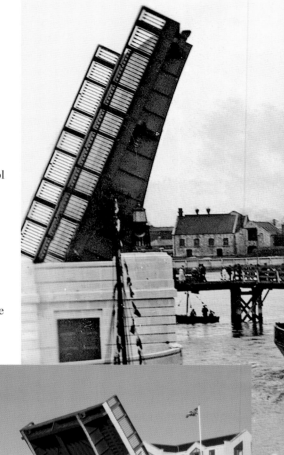

THE DUKE OF YORK (later King George VI) formally opened the Town Bridge on Friday 4 July 1930. Following a procession from the King's Statue, the Duke operated the machinery to raise the bridge, and Cosens and Company's paddle steamer *Empress* with school children on board passed through the bridge from the Backwater.

ON A SUNNY Sunday in November 2011 the Town Bridge is lifted to enable a yacht to pass on its way to the sea. The last paddle steamer went through the bridge in 1968, but the connection with young residents shown in the earlier picture is perpetuated as sea cadets are about to set out from the pontoon for boat handling instruction.

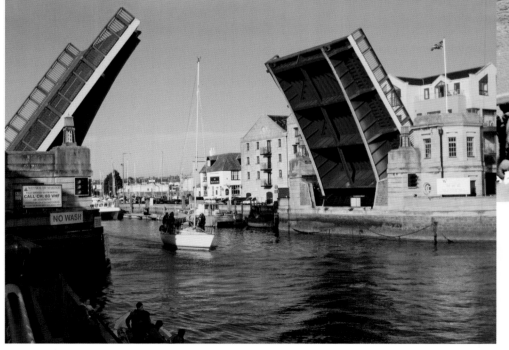

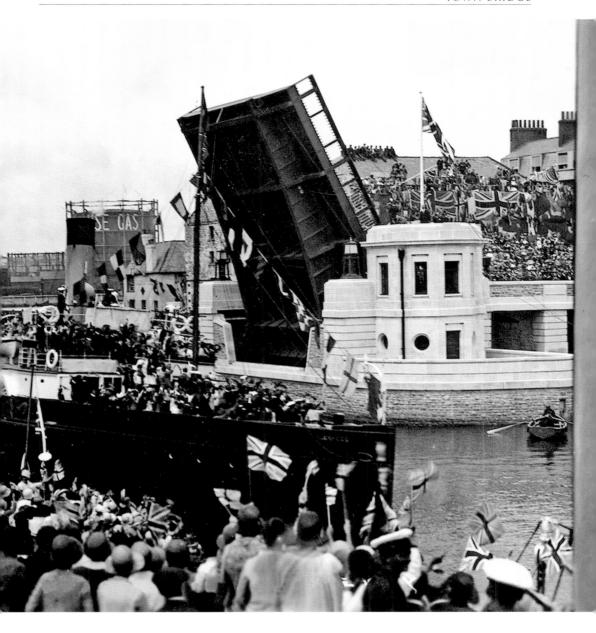

The gasworks, which are so prominent in the earlier picture, were demolished in 1962 and replaced by Westwey House. The area on the right, above the Town Bridge engine house, previously occupied by crowds of onlookers, lay undeveloped until the late 1950s when Town Bridge House, a utilitarian building occupied by government and local government offices, was built. This was completely remodelled in 2005 and is now occupied by a restaurant and apartments. The warehouse, which can just be seen under the right-hand leaf of the bridge, was restored and converted to residential use in the late 1980s.

TOWN BRIDGE

THE OLD TOWN Bridge, facing east from Ferry's Corner, before the motor age! This corner was so called because in the mid nineteenth century at the junction of Custom House Quay and Commercial Road there was a wheelwright's yard owned by Thomas Ferry and Sons. Eight years after the construction of the new bridge in 1930, Ferry's Corner was widened to reduce the sharp curve on the Harbour Tramway and to allow easier running for the trains as they moved towards the Quay Station.

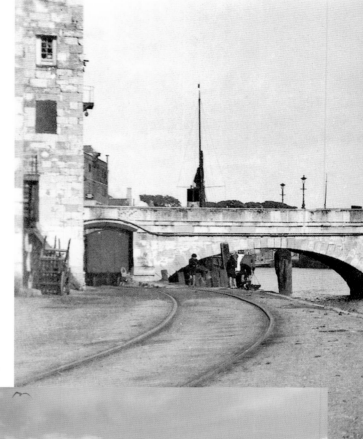

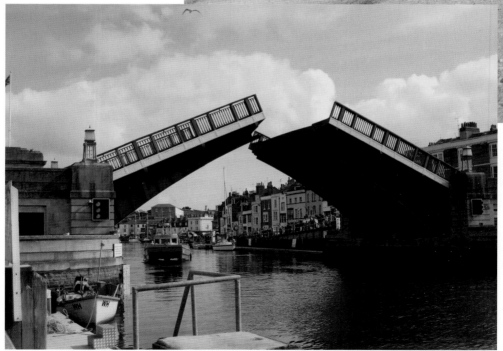

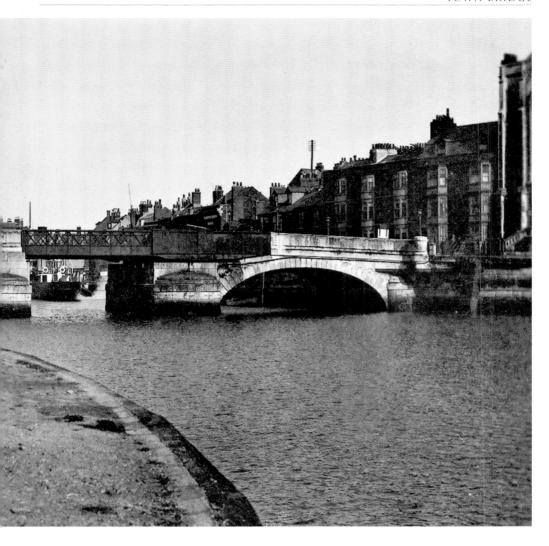

In the old photograph above, taken before the widening and the construction of the new bridge, it is easy to see the tight fit of the goods wagon as it goes under the arch. Some boys look as if they are about to launch a model yacht into the harbour.

THE 80TH BIRTHDAY of the 1930 Town Bridge was marked in 2010 by a number of events attended by some of the residents who had been present at its opening. It is now opened at regular intervals daily to permit the passage of pleasure craft to and from the inner harbour. Here MV *Freedom*, a vessel constructed for the use of disabled passengers, comes through at the 2pm lift. The raising of the bridge is a major attraction to visitors to Weymouth, who line the approaches to watch the yachts pass through. However, it is less of an attraction to some local residents, especially if such lifts happen during their lunch breaks and they are 'trapped' on the wrong side of the harbour!

LOOKING WEST FROM THE TOWN BRIDGE

AN ATMOSPHERIC VIEW looking west from North Quay. A train to Portland labours up the bank to Rodwell station and in the Backwater a small number of boats contrast with today's busy scene. Westwey Road has not yet been built, nor have the major extensions to the gasworks of 1932. Behind the Sidney Hall is the Recreation Ground, the home of Weymouth Football Club. Local residents will remember the army of gabardine coated fans that would surge out from the ground after the final whistle.

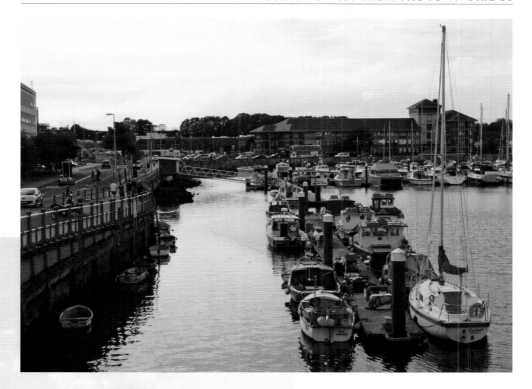

THE BACKWATER (rebranded as the 'Inner Harbour') was improved from 1970 by the installation of pontoons for the increasing number of pleasure craft. The skyline is much changed with the demise of the Weymouth and Portland railway and the growth of trees on the Rodwell Trail, which now runs along the former track bed. The demolition of the Sidney Hall means that the supermarket is also prominent in the left background. The gasworks ceased operation in 1958 and were subsequently demolished, with Westwey House Crown Offices being built on the site later. In 1995 this building was completely refurbished externally, which altered its appearance for the better. Traffic from Westwey Road waits at the newly installed traffic lights at the bottom of Boot Hill.

GIRLS' FRIENDLY SOCIETY HOSTEL, NORTH QUAY

THIS BUILDING WAS used as a hostel by the Girls' Friendly Society, a branch of which was run by Holy Trinity parish. It was renamed Sowter Lodge in honour of Canon Francis Briggs Sowter, vicar of Holy Trinity from 1885 to 1890. At the rear of the building was a hall, later known as the Sowter Hall, in which a number of activities connected with Holy Trinity Church were held.

THE SOWTER LODGE, together with some of the North Quay buildings, was demolished in the summer of 1961, with further demolition in 1965. The area was used as a car park until 1969, when work started on the construction of the new Municipal Buildings, a structure described as 'deplorable' in Pevsner's *Buildings of England*. Sadly, these demolitions took place a few years before local authorities and others were waking up to the need to retain interesting historic buildings. This area, responsibly conserved, would have been a great asset to the town.

OLD TOWN HALL

THE OLD TOWN Hall, High Street. Apart from the lack of railings and the replacement of the building on the extreme right (as a result of war damage) the scene looks remarkably similar today. The posters advertise a variety of attractions including Professor Lorenzo's Wonderful Dogs, a trip to Ascot Races and the customary auction notices.

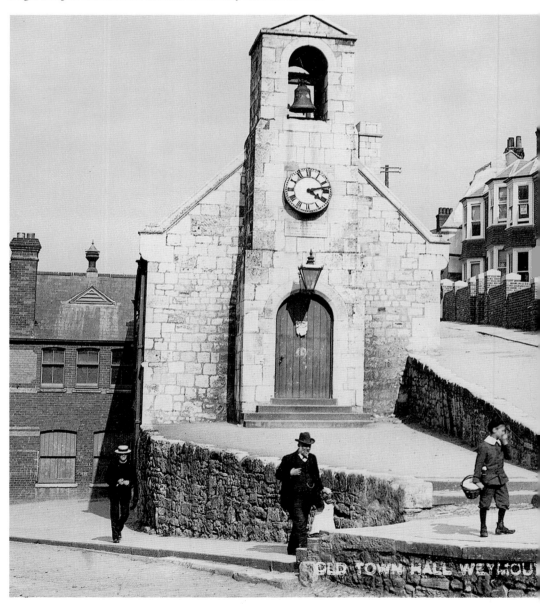

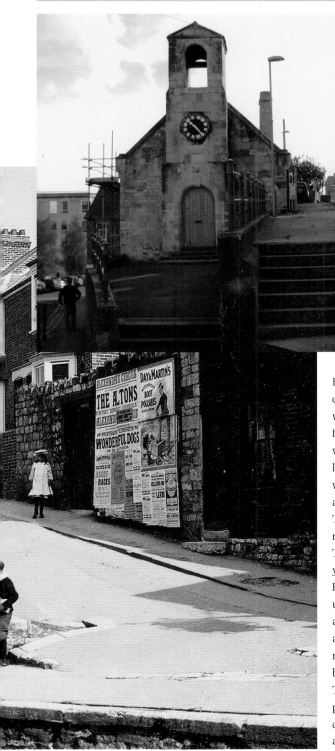

RAILINGS NOW PROTECT the entrance to the Old Town Hall. The wall containing the hoarding at the far right of the original photograph was burnt out in 1940 when a landmine fell on Chapelhay. Its ruins were demolished and replaced by a detached stone house in 1958. This has now been demolished and replaced by a terrace of new housing. The Old Town Hall was used for many years by the Girl Guide Association. Following their departure, it was left unoccupied and deteriorating. After a period of uncertainty, including a suggestion that the premises might be sold, the council leased the building to the Guardians of the Old Town Hall, who are making good progress in bringing it back to life as a community, arts and heritage centre after years of neglect.

SIDNEY HALL

THE SIDNEY HALL, at the corner of Newstead Road and Boot Hill, was opened in 1900 and cost £8,000. It was given to the parish of Holy Trinity by Sir John Groves, the brewer, in memory of his son, Sidney, who had died in 1895. It was intended for use by the Church Lads' Brigade in which Sidney had served as an officer. With the demise of that organisation the main hall was used for a variety of purposes, and the small hall at the rear was used largely for church activities. Following wartime damage to Holy Trinity School in Chapelhay, the Sidney Hall was used as temporary accommodation for its pupils. In 1987 the Sidney Hall and adjoining Recreation Ground were demolished and a supermarket was built.

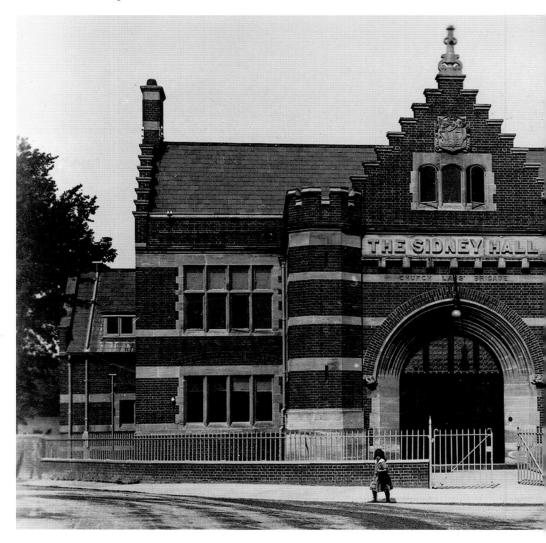

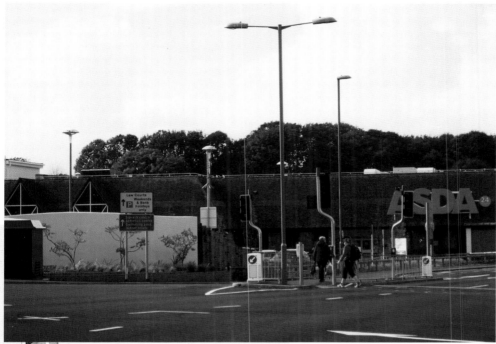

THE 1987 SUPERMARKET was upgraded in 2011 with the construction of a multi-storey car park and addition of a mezzanine floor. The original car park was redesigned and the front of the site shown in the previous photograph now houses a recycling compound for use of the general public. Happily, the coat of arms of the borough of Weymouth and Melcombe Regis, taken from above the front door of the original Sidney Hall, together with its foundation stone, has been preserved in the wall of the new structure. The current photograph was taken across the Boot Hill junction where in 2011 traffic lights replaced the roundabout installed in 1932, a change which led to voluminous correspondence in the local press, most of it highly critical.

MAIDEN STREET

THE CORNER OF Maiden Street and St Edmund Street, showing the premises of Hurdle's wine merchant and butcher's. The attractive cottages in the centre of the picture were demolished in the 1920s to allow an extension to Hurdle's shop.

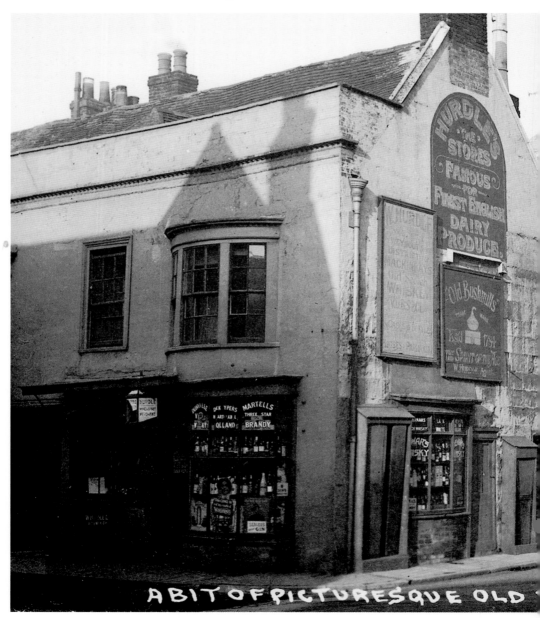

MOUTH.

HURDLE'S BUSINESS CLOSED in the early 1960s and the premises have since had a number of uses associated with the entertainment industry, as have Barlow's corn and seed merchants adjacent, having been at various times a taxi office, a restaurant and a delicatessen. In the late 1960s and early 1970s this corner was blighted by proposals for the construction of a road, but the scheme came to nothing. The modern scene is far less attractive than the earlier view.

PARK STREET

THE OLD PHOTOGRAPH shows Park Street in 1911. Specialist shops have now replaced the grocer's, baker's and tobacconist's, and many properties have now been converted to residential use. In the background is Christ Church, built in 1874. It had been affected by declining church attendances and a shortage of clergy by the 1930s, but an offer by a cinema chain to buy the site and re-erect the building in an area that needed a church was rejected. The newly-appointed rector closed the church in 1939, stating that it was in poor condition. It served as a British

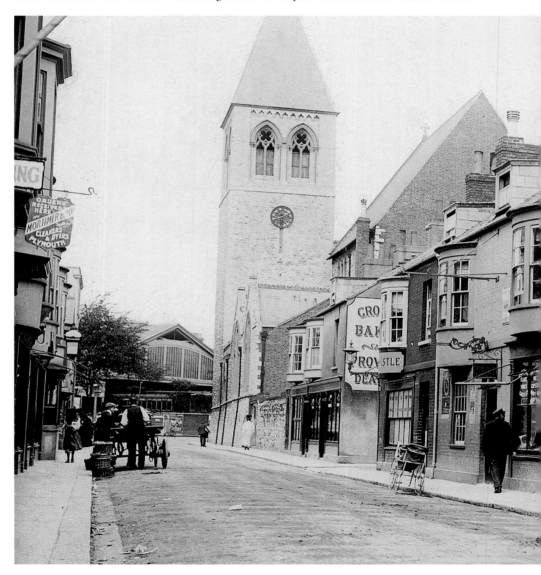

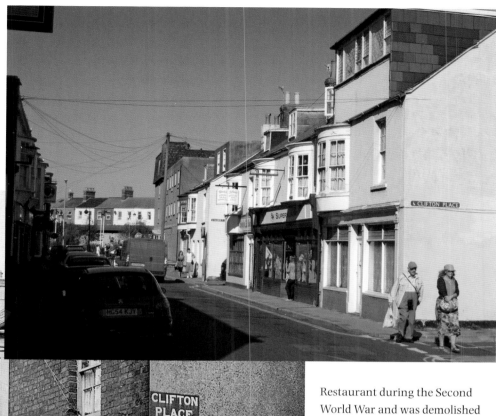

Restaurant during the Second
World War and was demolished
in 1956. The posters advertise
attractions such as excursions
to Killarney and London, and
Milledge's auction at Portland.

ONE HUNDRED YEARS later
Garnet Court, a block of flats,
has replaced Christ Church. The
present railway station can just
be seen in the centre distance.
Some shops in Park Street have
been converted to residential use
while others sell very different
wares than in earlier days. The
road is now heavily trafficked,
vehicles passing northwards from
Westham Road to King Street.
The sign for Clifton Place has been
replaced by a metal one.

RAILWAY STATION

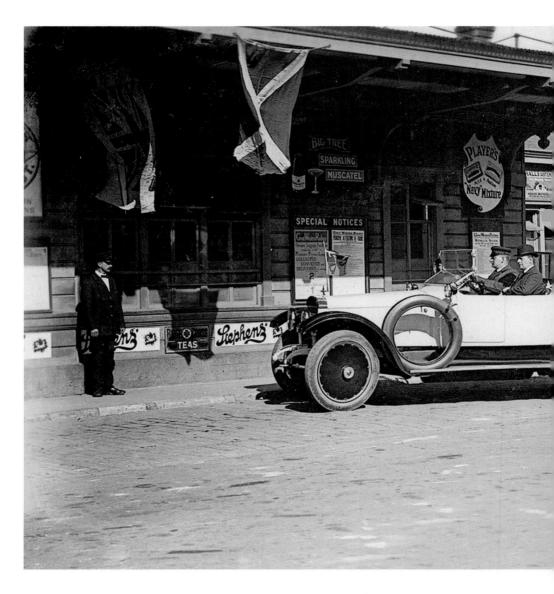

IN JULY 1923 the Prince of Wales (the future King Edward VIII) visited Weymouth and Dorchester; he is seen in the old photograph returning to Weymouth railway station accompanied by Mayor Cllr W.J. Gregory, in time to catch the 5.20pm train. The crowd control appears to have been extremely effective as none is visible! The building is adorned with enamel signs advertising Pears Soap, Player's Navy Mixture tobacco and other products. Such signs today are highly prized by collectors!

THE RAILWAY STATION, opened on 20 January 1857, continued in use for almost 130 years. The Great Western Railway plans for a new station in the 1920s and 1930s came to naught, the railway company officials accusing the borough council of prevarication and then the Second World War curtailed further negotiations. The overall roof was demolished in 1951 and a new platform opened adjacent to Ranelagh Road in 1957. The original station was demolished and the site redeveloped with a more compact layout. The new station came into use in 1986, using the 1957 platforms as its core. The demolition of the old station buildings has opened up the view of the Clifton Hotel, which is only identifiable in the previous picture by the chimneys. It has now been renamed the Railway Tavern. The original station had remained lit by gas until the 1960s, so evening passengers were treated to a scene in which Sherlock Holmes would have felt entirely comfortable!

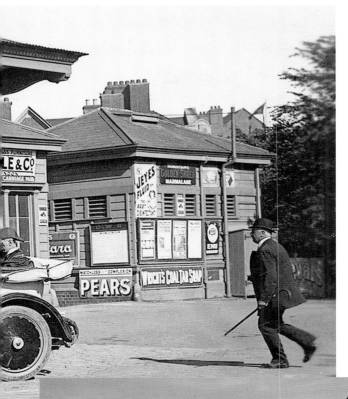

SWANNERY

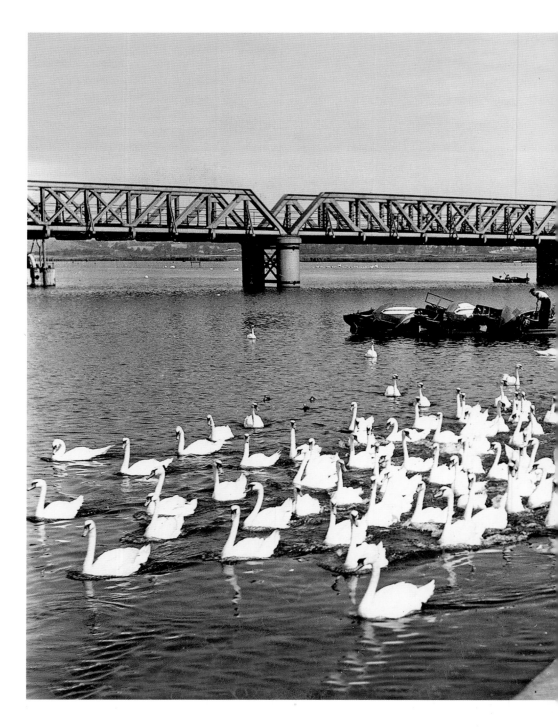

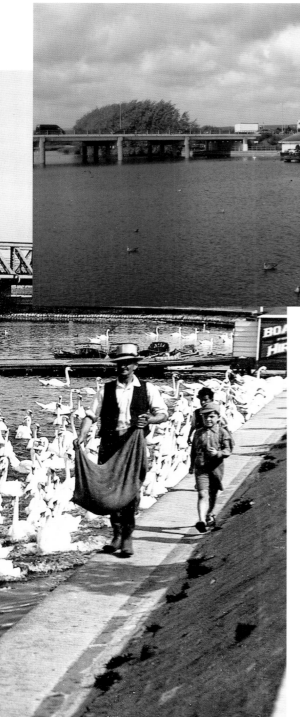

THE SWAN HERD followed by youthful volunteer apprentices comes to feed the swans at the side of Radipole Park Drive in the 1930s. On the far left of the picture (underneath the bridge) can be seen the stern of the dredger that periodically kept the reeds down in Radipole Lake. A local competition was run to give it a suitable name – one suggestion was the *Dredgenought*! The condition of this vessel deteriorated and it was eventually scrapped.

SWANS STILL FREQUENT this area of the town, although they were not so evident on the day this photograph was taken. The viaduct was demolished in 1974 and its site is now occupied by the Swannery Bridge, which opened in 1987 as part of the Weymouth relief road scheme (first mooted in 1933). The building, designed to give the appearance of a vessel, is in fact a heavily disguised concrete plinth. It was first opened as an aquarium, but has seen use as an amusement arcade and more recently as a restaurant.

MELCOMBE REGIS STATION

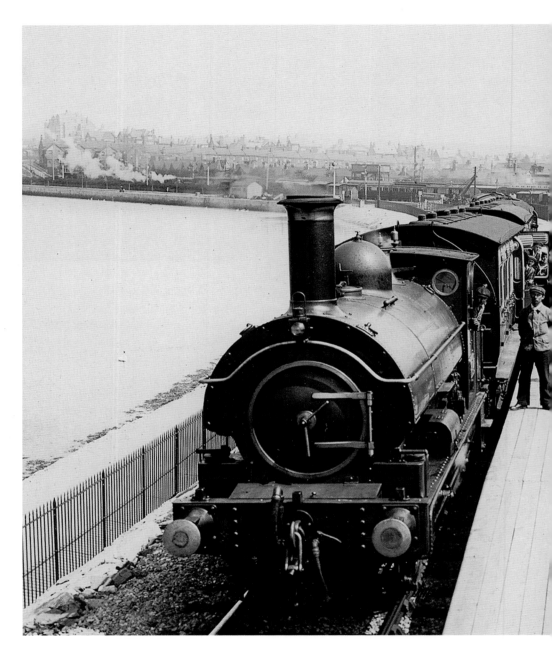

A GWR 850 class 0-6-0ST locomotive waits to depart from the newly-opened Melcombe Regis station during 1909. Over the years, infilling of Radipole Lake has changed the scene.

THE MODERN PHOTOGRAPH shows just how this area of Weymouth has changed. The railway line to Portland was closed in 1952 to passengers and to freight in 1965. In the intervening period Melcombe Regis station was used occasionally at busy summer weekends as an overflow station for Weymouth. The site of Melcombe Regis station was obliterated in 1983 with the construction of a new roundabout and road bridge. Following the redevelopment of the Weymouth railway station, the site of many of the railway sidings became the Jubilee Business Park. At the time of the photograph the traffic system had just been amended with the removal of the King's Roundabout and the introduction of traffic lights.

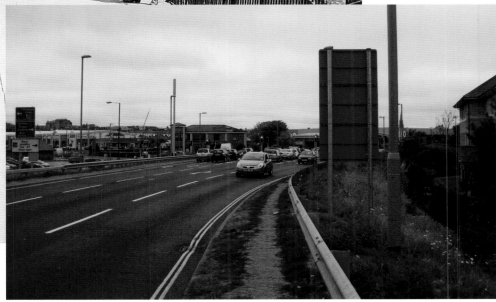

WYKE SQUARE

THE OLD PICTURE shows Wyke Square sometime after 1905, the date of the erection of the first gas lamp in the square. In the centre is the Albert Inn. Adjoining the Swan Inn can be seen the entrance to Hamilton House, one time property of James Hamilton, who designed many of the public buildings in Weymouth including St Mary's church. Next to this is the entrance to the slaughterhouse.

THE MAJORITY OF the buildings in the earlier photograph still exist although many have

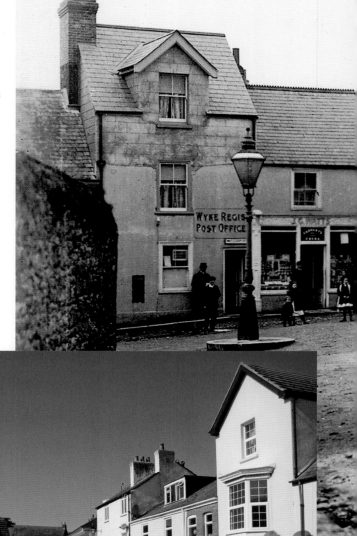

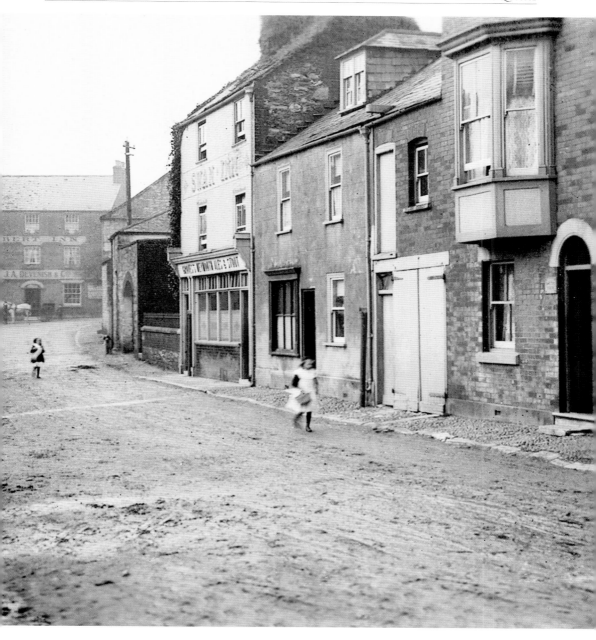

changed their guises. The Swan Inn is now in residential use and there is no longer a post office. The Old Wyke Village Stores closed at the end of 2011. Wyke Square is now part of a conservation area, and the Wyke Regis Protection Society keeps a protective eye on this part of the borough. One cannot but think that the flower tubs would not have existed in the earlier photograph when the village was much more an area for business. Each year a very successful Christmas event is held in Wyke Square.

RODWELL STATION

A PRE-1914 view of Rodwell station on the Weymouth–Portland branch, shown after its reconstruction with a passing loop during 1907. A GWR saddle tank awaits departure with a Weymouth-bound train. Posters on the station advertise excursions to Swanage. To the left of the station flower plots can be seen; the station was a frequent winner in the Best Kept Station competition. Although not visible in the photograph, a greenhouse was situated on the platform, which no doubt helped the station's success. These flowerbeds lasted until the Second World War when they were used for vegetable cultivation; as well as being for their own consumption,

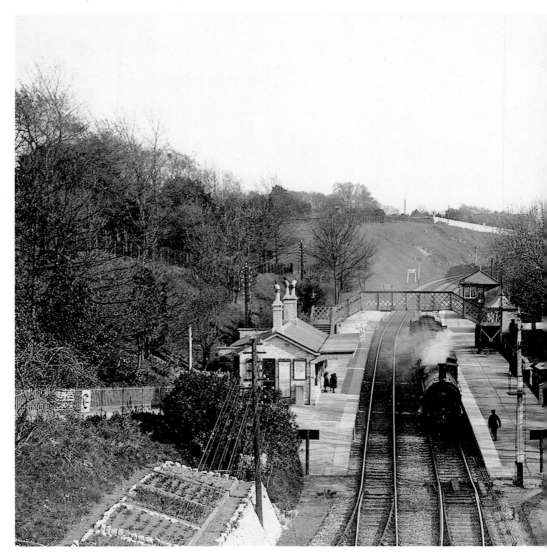

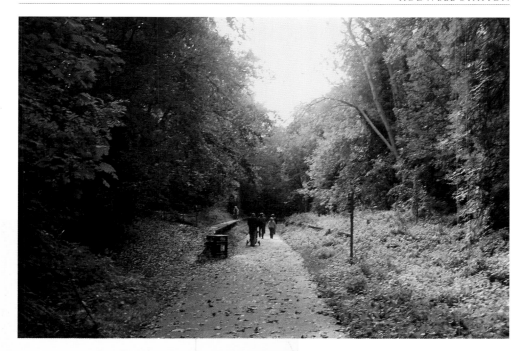

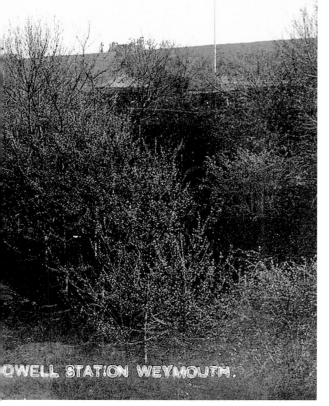

DWELL STATION WEYMOUTH.

station staff used the vegetables to feed the rabbits they bred to help eke out the meat rations!

THE REMAINS OF Rodwell station are now on the Rodwell Trail, which runs from Westham to Wyke Regis along the path of the former railway to Portland. In the 1970s this had been proposed as the site of a relief road to carry some of the vehicular traffic to Portland, but this scheme was subsequently dropped by the county council. There are few remains of the stations on the route. However, at Rodwell the platforms are still evident although there is considerable ground cover all around and the trees have grown to provide a shady arch for the many pedestrians and riders who use the Rodwell Trail. The density of trees in the area today makes photography from the same spot difficult.

NEWTON'S COVE

NEWTON'S COVE LOOKING towards the Nothe in the 1920s. A big expansion of Great Western shipping traffic had taken place by the late 1880s. The company had looked for alternative accommodation and decided to build a new harbour with connecting railway at Newton's Cove. Despite opposition from the council, which stood to lose revenue, the appropriate legislation was passed in 1898. The scheme was abandoned in 1913 but not before a public house, optimistically named the Railway Dock Hotel, had been built in 1902.

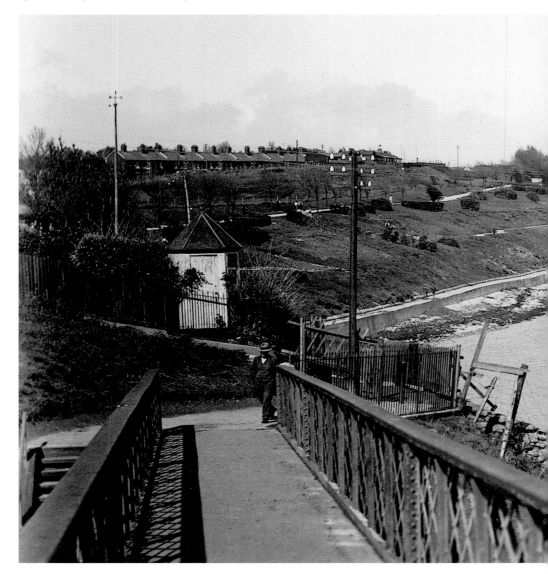

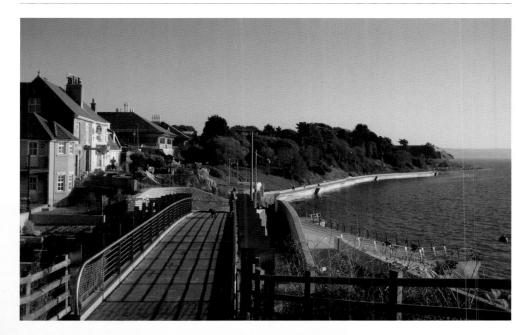

ALTHOUGH THE SEA and general area look roughly similar in both photographs, since the 1920s Newton's Cove has been the potential site for first a hovercraft terminal and then a marina. Both schemes were abandoned before any construction work was undertaken. The Underbarn Walk has suffered from coastal erosion but was the subject of a major sea defence works scheme, and it is a now a popular walk. The pedestrian bridge has been replaced twice, most recently in 2009. In the Nothe Gardens the DEFRA buildings are prominent, and recently further residential buildings have been erected in the area.

SUTTON POYNTZ

THE MILL POND at Sutton Poyntz, with little disturbing this idyllic view. The chimney is part of Sutton Poyntz water-pumping station and dates from 1897. By the 1950s some of the cottages were in poor condition but were rebuilt in a sympathetic style.

THE MODERN VIEW of Sutton Poyntz appears, to the casual observer, not very different from the earlier one. However, Preston and Sutton Poyntz were integrated into the borough of Weymouth and Portland when the boundaries were extended

in 1933, and in the early 1970s Sutton Poyntz was designated a conservation area, thus enhancing controls over unsuitable development. The Sutton Poyntz water-pumping station now houses a water museum. The pumping station contained a section of discarded funnel from Brunel's great paddle steamer *Great Eastern*. She had put into Portland in 1859 for coaling following an explosion on board. The funnel was used as a strainer at the waterworks but in 2005 it was moved to the *Great Britain* site in Bristol.

PRESTON
BRIDGE

A GREAT WESTERN Railway
Maudslay bus heads from
Preston towards Weymouth
in 1922. Preston was then
a small village outside the
borough; in 1931, two years
before the borough boundaries
were extended to include the
village, the population of
Preston was only 855. The
developments off Coombe
Valley Road and at Southdown
started in the late 1950s.

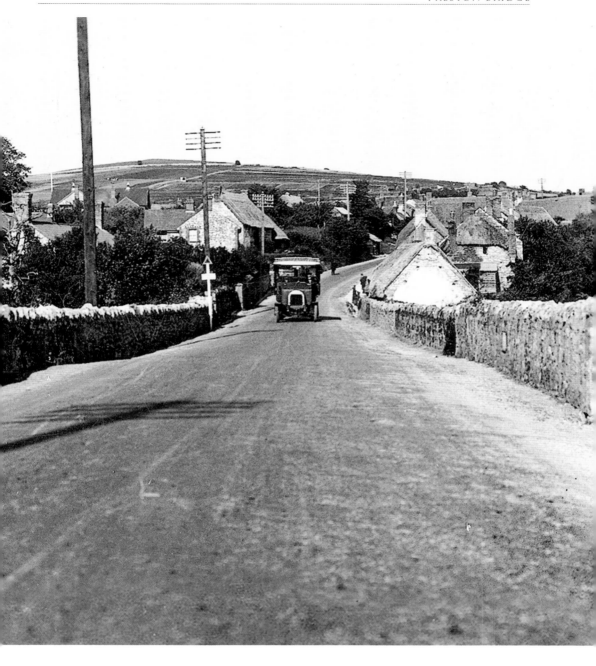

THE BEND IN the road leading to Osmington Hill is still there although the road has been widened and the wall on the right demolished. Since the 1920s, Preston has grown and now has residential properties in most parts of the parish, as can be seen by the houses in the centre of the picture. Since the Second World War, the fields, above the buildings on the right, used in the 1930s for camping have been developed with holiday chalets and caravans.

BOWLEAZE

THE OLD PHOTOGRAPH shows Bowleaze Cove in 1929. Soon after, the area started to develop as an attractive alternative to the main beach, and campsites, and later caravan parks, were developed in the cove. The art deco Riviera Hotel was built in 1937.

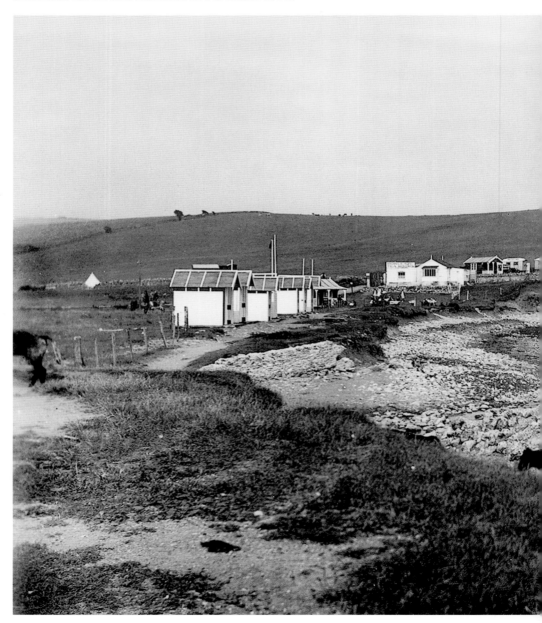

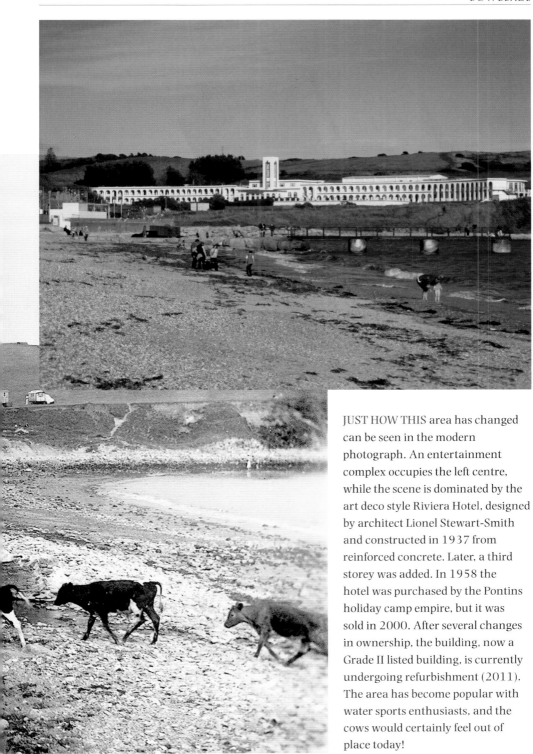

JUST HOW THIS area has changed can be seen in the modern photograph. An entertainment complex occupies the left centre, while the scene is dominated by the art deco style Riviera Hotel, designed by architect Lionel Stewart-Smith and constructed in 1937 from reinforced concrete. Later, a third storey was added. In 1958 the hotel was purchased by the Pontins holiday camp empire, but it was sold in 2000. After several changes in ownership, the building, now a Grade II listed building, is currently undergoing refurbishment (2011). The area has become popular with water sports enthusiasts, and the cows would certainly feel out of place today!

VICTORIA GARDENS

A TRACTION ENGINE, its trailers loaded with stone, passes Victoria Gardens on the way to F.J. Barnes' sawmills in Victoria Square in 1924. The writer of the card comments 'this is where you land on the bus from Weymouth'. The vehicle was later owned by Richard Townsend's Amusements of Chickerell and rebuilt by Eddisons of Dorchester as a showman's engine, 'Queen Mary', and is now in preservation.

THE POLICE STATION and court buildings are still prominent in this picture, but behind them is

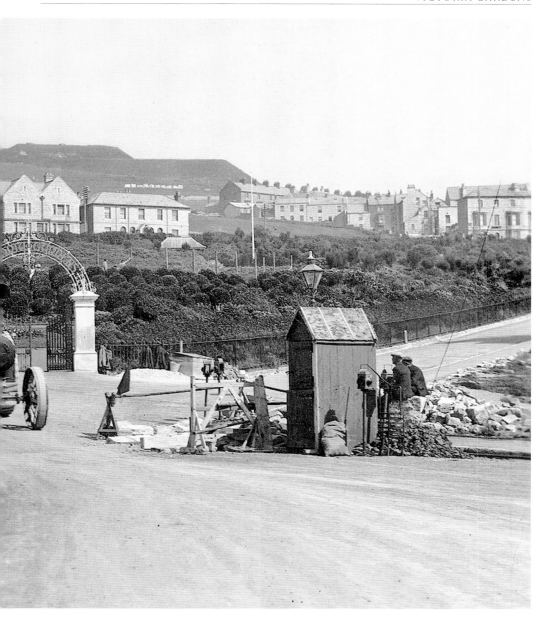

the large Verne Common council estate developed by Portland Urban District Council in the 1950s. The council was an enthusiastic developer of municipal housing. The entrance to the garden has been realigned, and behind the road direction signs is a memorial, unveiled on 22 August 1945 by John G. Winant, US Ambassador to Great Britain. The stone commemorated the 418,585 troops and 144,093 vehicles that passed this spot during June 1944 on the way to the D-Day landings. As a result, Cadets Road at the left of the picture was, appropriately, renamed Victory Road.

SALVATION ARMY, CASTLETOWN

THE SALVATION ARMY Sailors' Home and Score's Steam Bakery and Naval Contractors and Ships Chandlers, Castletown, in the 1920s. The writer of the card comments 'the rails are not tram lines – can't afford them down here but a four wheeled vehicle which carries slabs of rock upon it now uses it.'

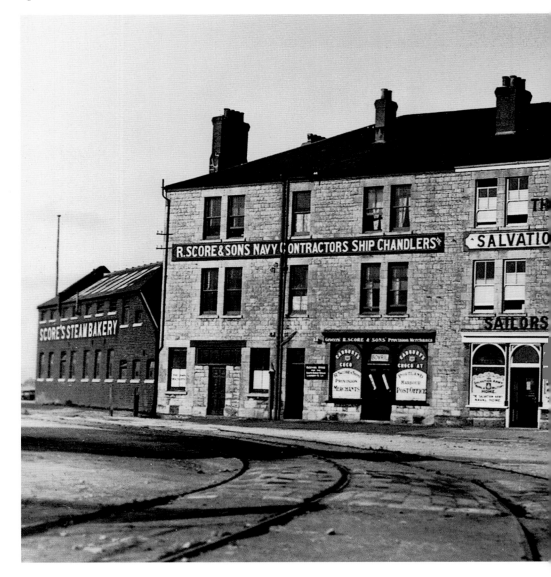

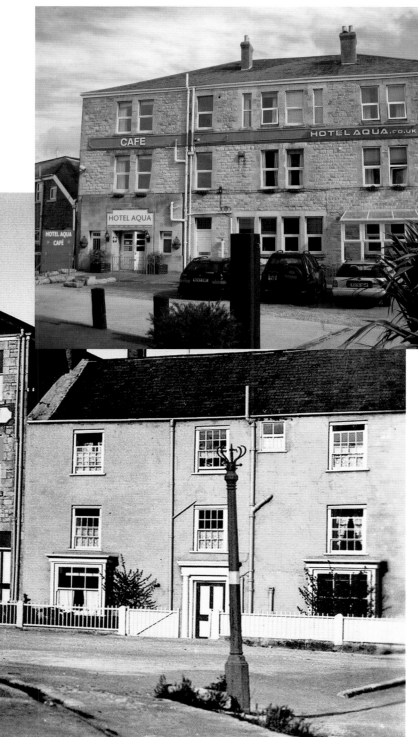

THE USE OF the Salvation Army Sailors' Home declined with the phased departure of the Royal Navy from Portland from the 1980s. The hostel, together with Score's ship chandlers, is now a hotel catering for the increasing number of recreational divers using Portland harbour. The railway lines, a reminder of the quarry railways and transhipment of stone, have long since gone.

CASTLETOWN

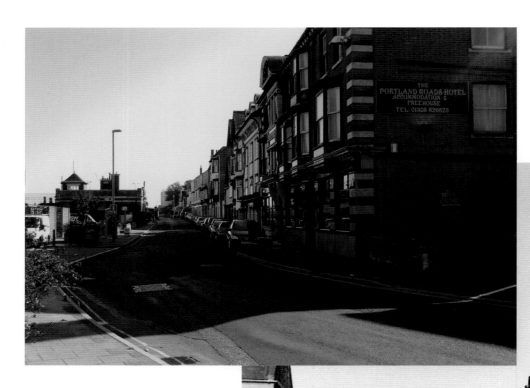

AROUND 1930 A sailor crosses the road in front of the ornate Portland Roads Hotel, with the name of the local brewery, J.A. Devenish, proudly sculpted into the façade. A number of his shipmates head along the street, perhaps in eager anticipation of sampling the local brew at one of the many establishments in the street. Hopefully their activities will not bring them to the attention of the Naval Patrol, which was active when the fleet was in port, dealing with service miscreants who had sampled the local brew too liberally. The Naval Patrol was feared by servicemen, and indeed by some locals as the patrol assisted the civilian police on rowdy Saturday nights!

CASTLETOWN IS STILL recognisable as a classic 'Dockyard strip' familiar in many naval towns. It still has the imposing hotels and inns which were built in the late nineteenth century to serve the Dockyard. Second in, the Royal Breakwater is unaltered, its main frontage, facing the harbour, has a rich composition characteristic of turn of the century design. It is now a listed building. The Portland Roads pub still carries the Devenish name – as indeed do many of the company's public houses of that era, as the architect made a special feature of it.

With the departure of the Royal Navy from Portland, the harbour was sold to Portland Port Ltd., and a wide range of commercial shipping catches the eye when one passes along Portland Beach Road. The occasional cruise ship brings tourists keen to explore the surrounding countryside. The Weymouth and Portland Sailing Centre is home to the sailing activities of the 2012 London Olympics and many visitors are anticipated.

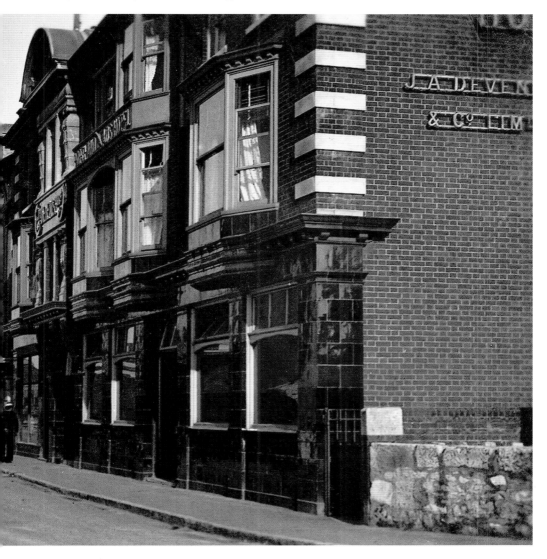

CASTLETOWN PIER

CROWDS SWARM ASHORE from Cosens paddle steamer *Premier* at Castledown Pier before 1914. Stone awaits shipment from wagons on the pier. Although built in 1846, the *Premier* had nearly thirty years more of life, not being withdrawn until 1938. This was a popular

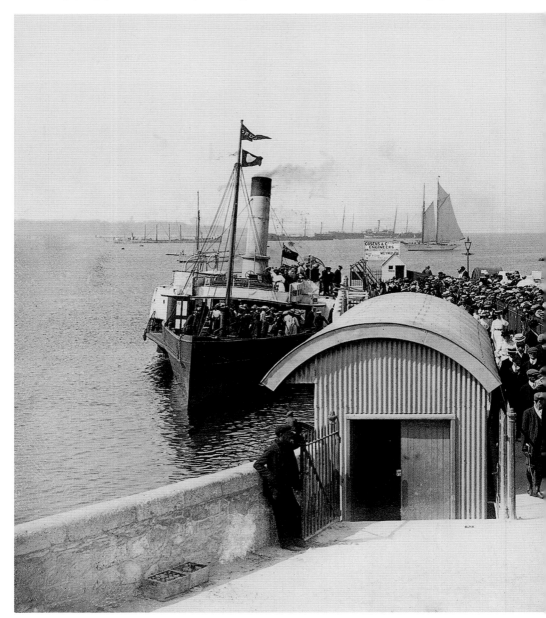

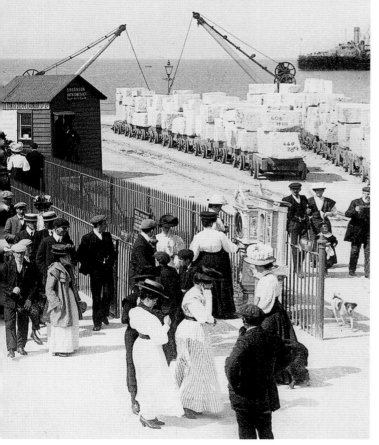

destination, seven trips being made daily in the summer season. It is perhaps surprising to find amusement machines at this location. Coal hulks lie at anchor in the background.

THE THRONGS OF visitors have long since departed as have the paddle steamers. This is now an industrial area. However, in 1964 the PS *Princess Elizabeth* and Cosens' PS *Consul* called with visitors from Weymouth for Portland Navy Days. Using a jetty near Portland Castle, small pleasure craft such as *My Girl* still carry on a designated service to Portland from Weymouth Harbour during the summer months.

FORTUNESWELL

FORTUNESWELL WAS THE main shopping area for Underhill, although this is not evident from the lack of residents in the photograph. D. Lawrence, the butcher, is proud of his appointment as a Government Contractor. On the opposite side of the road is a leather goods merchant, a trade seldom seen today.

THE DECLINE OF Fortuneswell as a shopping area over the last forty years has been noticeable, and the majority of businesses are now centred on Easton. A British Telecom phone box is prominent

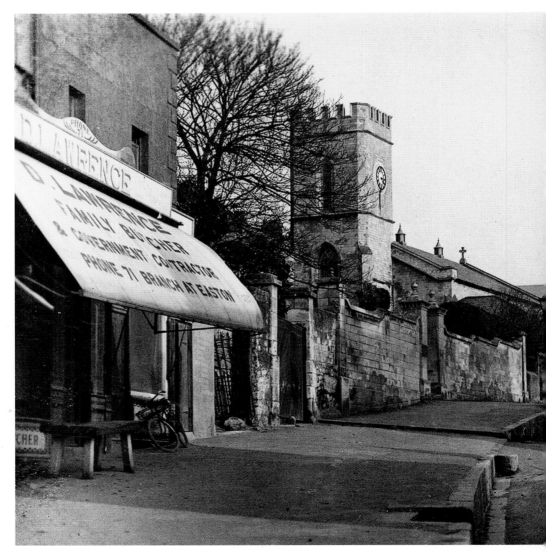

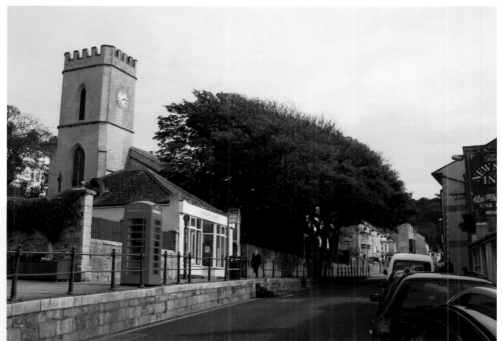

on the pavement and the trees in St John's churchyard have grown in size. St John's church, built in 1839, continues to be a prominent feature in the street, and the clock in the church tower serves as a public clock – the maintenance costs being met originally by Portland Urban District Council and latterly by Weymouth and Portland Borough Council. The butcher's shop of the earlier photograph has long since disappeared, and the single-storey building outside of the church is now a coin operated self-service laundry, having been successively a draper's shop and a café. Railings to protect pedestrians from falling off the pavement into the path of the increasing volume of motor traffic have also been erected.

NEW ROAD

WILLIAM MOORE AND his son were contracted to build a new highway between Priory Quarries and Underhill in 1810. This view, taken from above Tillycoombe in the 1920s, shows New Road and Old Hill. Whilst Old Hill was no longer used for vehicular traffic, in the 1960s the then Clerk of the Urban District Council exercised the legal right to drive his car up this ancient highway.

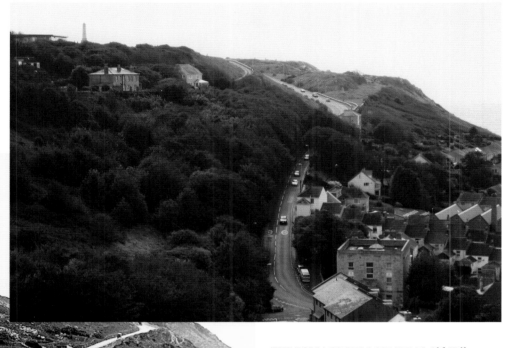

THE FOLIAGE SURROUNDING Old Hill
has grown up, considerably altering the
landscape on the south side of New Road.
The three gables and chimney of the former
Portland Steam Laundry, which opened
in 1905 and at the time was described as
having 'the most modern appliances', are
still prominent. Since the closing of the
laundry, these premises have served as
an engineering works, and in 2010 the
building opened as an arts centre. The line
of New Road shown in the first photograph
was resting on an old stone tip. Following
erosion and ground movement, New Road
was diverted inland and the notorious
Priory Corner bend was improved greatly
by a scheme completed in 1996. On the
right-hand side of the hill a Portland
Stone statue, 'The Spirit of Portland', to
commemorate the character of Portland, was
erected in 2000. This was carved by artist
Joanna Szuwalska and depicts the historic
island trades of quarrying and fishing.

EASTON STREET

EASTON, LOOKING TOWARDS the
Grove. This was a vibrant shopping
area for residents of Tophill and
the street included such trades as
grocers, confectioners, ironmongers,
drapers and hairdressers. Outside the
Punchbowl Inn a cart stands; possibly
the driver is sampling the local brew
for which this hostelry was noted.
This was brewed on the premises
using water from the Great Pool and
was brought in buckets to the inn.
Flagons of ale were regularly taken to
the quarries to slake the thirst of the
workforce. In between the shops were
cottages, a number of which were
occupied by quarrymen whose labour

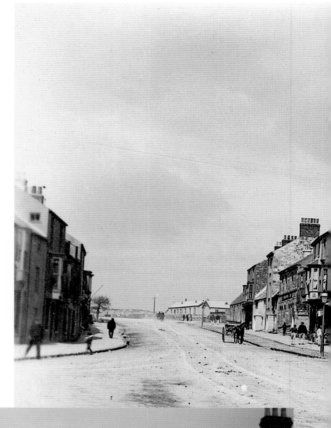

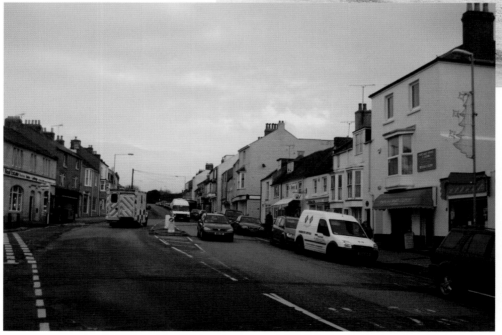

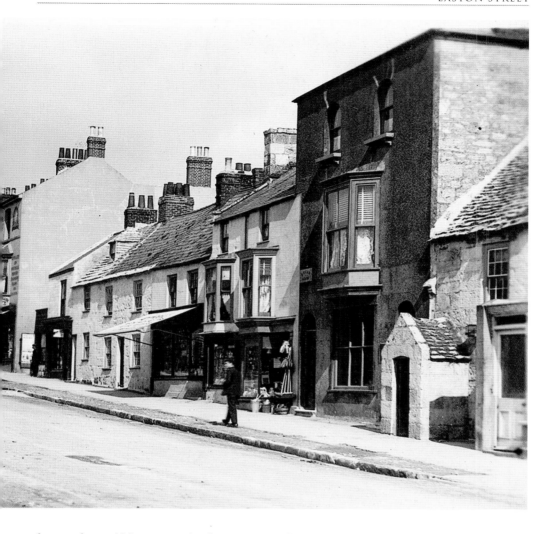

dug out the world famous Portland Stone. Some of the cottages possibly date from the early seventeenth century.

SINCE THE GRADUAL decline of Fortuneswell as the main shopping street, Easton has become the shopping centre for the island. The street scene is largely recognisable and the third shop on the right even has an awning as it did in the earlier picture! However, the motor age is very much apparent and while such a development could not have been anticipated, the roads are of a generous width. The opening, adjoining the cream building half way along the street, is the entrance to a development known as Foundry Close, perpetuating the name of F.J. Barnes foundry, the site of which was occupied from 1938 to 1988 by a purpose-built fire station, which was itself replaced by a new structure in Grove Road. The shop with the red blind, which is now a sports shop, was converted from a private house. Unfortunately the picturesque cottage immediately to its right in the earlier picture, with its typical Portland porch, has been demolished.

EASTON GARDENS

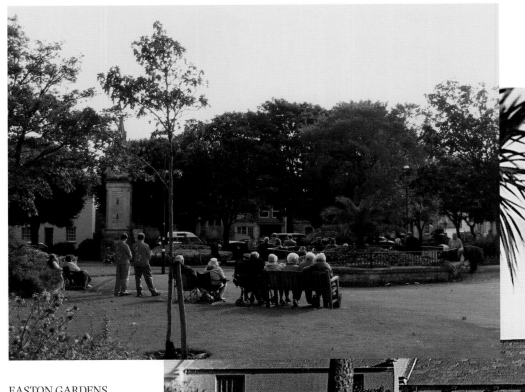

EASTON GARDENS, SHOWING the clock tower and bandstand. Easton Gardens, laid out in 1904, provided a focal point for Easton. The bandstand, upon which band concerts were given for sixty years, was removed in 1965 due to lack of maintenance.

CONTINUING THE LINK with the past, on an early autumn Sunday afternoon the Salvation Army holds an evangelistic service in Easton Gardens.

The Portland Corps of this organisation was established in 1885 following a meeting held in Easton Square. Currently the Salvation Army shares the buildings of Easton Methodist church on the corner of Easton Square and Reforne. The base of the bandstand in the gardens has now been planted with flowers although the superstructure itself has been demolished. The gardens fulfil a useful purpose in the area, with facilities such as a children's play park. A one-way traffic system around two sides of the gardens was implemented in 2011 with the construction of a new supermarket in Park Road. The stone clock tower, unveiled in 1907 from funds raised by public subscription started by the chairman of Portland Urban District Council, is still a prominent feature.

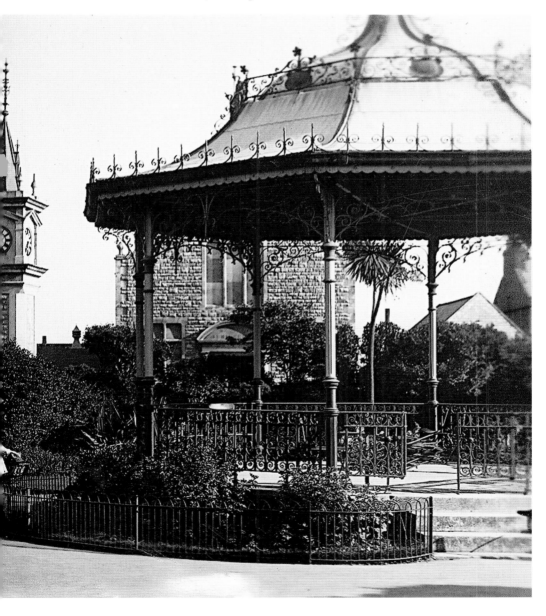

WESTON POND

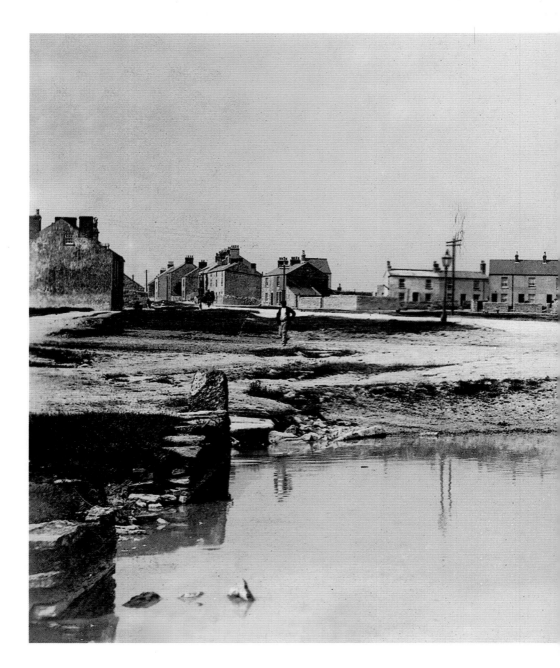

WESTON LOOKING NORTH around 1900, with a fine cast-iron lamp standard casting its
reflection in the pond. Ponds were common in the villages in Tophill and were fed by natural

watercourses. Portland Urban District Council, established in 1895, was a very forward thinking body, and a piped water supply was commissioned in 1902, leading to the disuse of various village ponds.

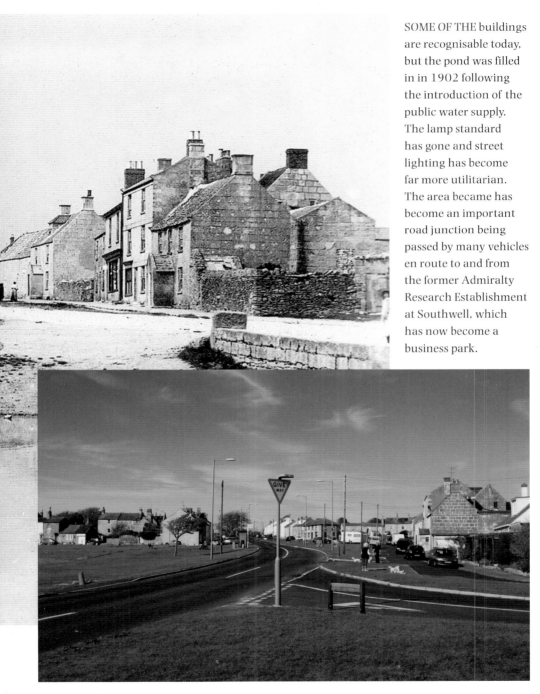

SOME OF THE buildings are recognisable today, but the pond was filled in in 1902 following the introduction of the public water supply. The lamp standard has gone and street lighting has become far more utilitarian. The area became has become an important road junction being passed by many vehicles en route to and from the former Admiralty Research Establishment at Southwell, which has now become a business park.

CAPTAIN'S HOUSE

THE CAPTAIN'S HOUSE, a small eighteenth-century mansion, was never actually built for a captain but was built originally for a wealthy stone merchant. After many years of dereliction, it was restored in the 1990s.

THE CAPTAIN'S HOUSE, now a listed building called Claremont, basks in the sunshine of an October day in 2011. Its restoration in 1997 meant the loss of a curiosity in the street scene of

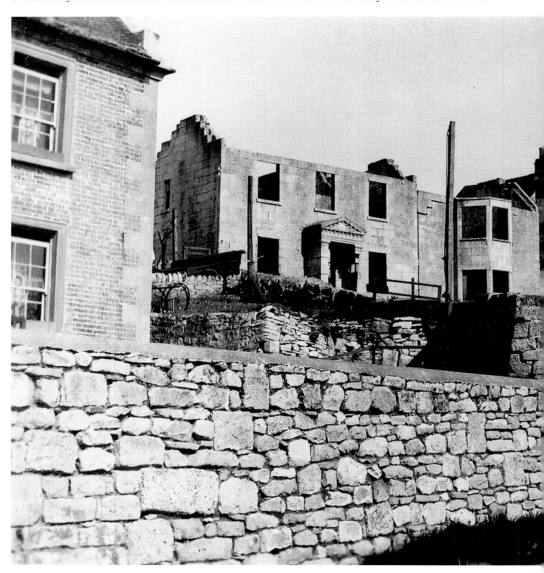

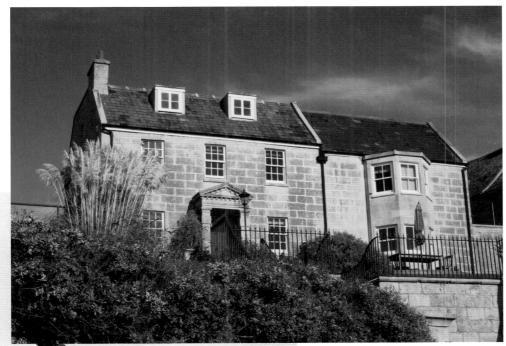

Underhill but the addition of a much admired residential building. There are a number of stories concerning the history of this house, which stood derelict for over a century. One was that it belonged to a sea captain whose fiancée died, and, heartbroken, he left the building uncompleted. Other tales report that it belonged to a Dr Motyer, who preyed on people's gullibility and ignorance about medical matters. Following one of his experiments, it was reported that the building exploded, covering the streets with specks of gold, but that the local residents never divulged this as they were afraid that people from Tophill would come to claim the spoils. Whichever story is true, or even if none of them are, the building is certainly interesting.

LITTLE BRANDY ROW

A THATCHED COTTAGE in Little Brandy Row. The thatch reeds possibly came from nearby Radipole Lake. Behind the cottage is a small courtyard giving access to a number of other small properties. Whilst the building was partially demolished in 1905, the doorway remains in the wall of a fisherman's store.

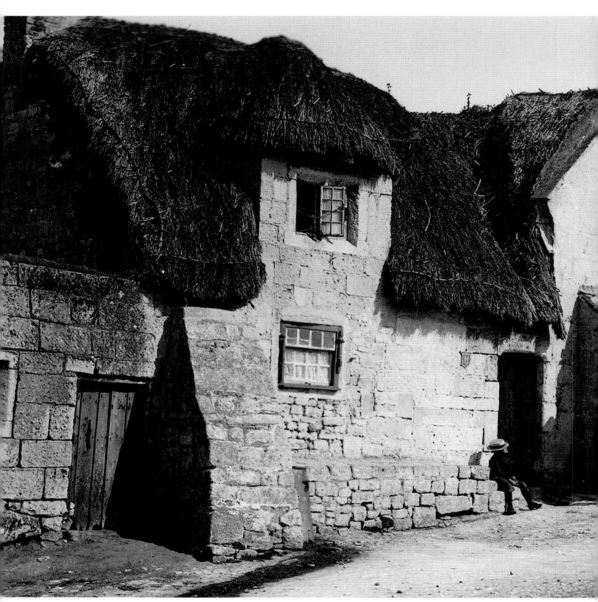

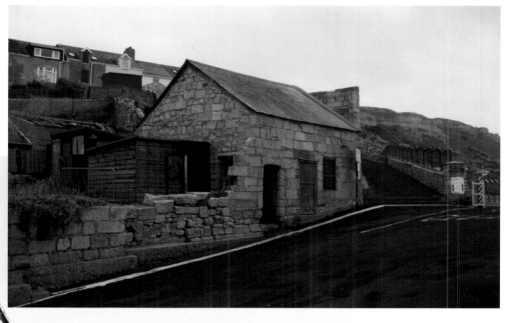

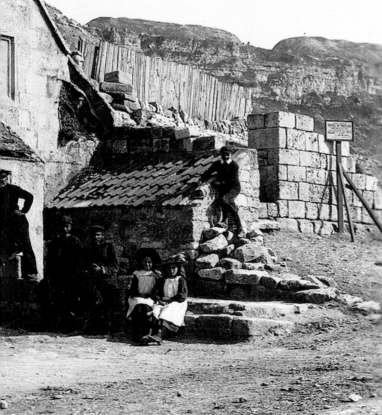

IT IS SAD that it is no longer possible to view structures shown in the earlier picture. Portland Urban District Council, as mentioned earlier, took its responsibilities for housing and public health very seriously and adopted a vigorous programme prior to the Second World War, demolishing properties which they considered sub-standard. Many buildings in the area fell victim to this policy; with the wisdom of hindsight, it is hard to ignore what an attraction to tourists and residents they would have been, had they lasted into the conservation era.

CHISWELL

A SCENE FROM the 1920s showing
a woman pushing a pram along the
middle of a street when it was safer
to do so than it is today. The building
on the left is a chapel built for the
Primitive Methodists in 1858.
This denomination was popular
on Portland, and its influence
attempted to control boisterous
activities of service personnel
stationed there. The stone building
in the middle of the street is a
cistern for storing water.

THE KINGS ARMS (on the right
in the original postcard) is now a
private residence, as is the Methodist
chapel. The cistern, the use of which
declined with the introduction of
a piped water supply, is long gone.
The road at Chiswell is now part

of a gyratory traffic system for Underhill which was introduced in 1960. The motor age is very apparent with the establishment of a car park. Many Portlanders will fondly remember Chiswell as the site for Portland Fair, the origins of which date back to at least the thirteenth century. It had been an annual event in Chiswell since the 1860s, but moved to a new site in 2006.

The shopping area of Chiswell thrived in the early years of the twentieth century, and indeed a directory of 1965 listed such trades as ironmonger, grocer, butcher and greengrocer. The retail aspect gradually declined and the area is now largely residential. However, Chiswell retains much of its character.

Other titles published by The History Press

Haunted Weymouth
ALEX WOODWARD

This collection of ghostly goings-on and paranormal happenings is a mixture of personal accounts and well-researched local legends, with many of the stories backed up by the town's rich, and sometimes bloody, history. Drawing on historical and contemporary sources, *Haunted Weymouth* is sure to send a shiver down the spine of anyone daring to learn more about the haunted history of the area and includes many previously unpublished stories.

978 0 7524 6046 8

Along the Dorset Coast
RAY HOLLANDS

Ray Hollands has walked the entire Dorset coastline to capture its unique atmosphere through his eye-catching photography. The dramatic and constantly-changing nature of this part of Britain's coast is depicted here, as well as an eclectic mix of bays, harbours, cliffs and beaches, and the stunning countryside bordering the sea. From bustling resorts, like Bournemouth and Weymouth, to places of quiet solitude, all are shown to great effect here and *Along the Dorset Coast* is sure to capture the imagination of anyone who knows and loves the county.

978 0 7524 5185 5

Dorset Murders
NICOLA SLY

Life in the largely rural county of Dorset has not always been idyllic, for over the years it has experienced numerous murders, some of which are little known outside the county borders, others that have shocked the nation. These include arguments between lovers with fatal consequences, family murders, child murders and mortal altercations at Dorset's notorious Portland Prison. *Dorset Murders* will appeal to anyone interested in the shady side of county's history.

978 0 7509 5107 4

Bournemouth Then & Now
JOHN NEEDHAM

Bournemouth has developed from a small seaside town into a major South Coast resort and bustling centre of commerce. Beautiful archive images are contrasted with modern photographs to show how Bournemouth has changed. From the gardens as they originally appeared, freshly laid out with a large fountain where the balloon now stands, to the East Cliff Lift, and the peaceful surroundings of the 'Invalids Walk', *Bournemouth Then & Now* will rekindle fond memories for many Bournemouth residents, and will delight residents and visitors alike.

978 0 7524 6792 4

Visit our website and discover thousands of other History Press books.

www.thehistorypress.co.uk

The
History
Press